BEGIN TO DRAW
PEOPLE

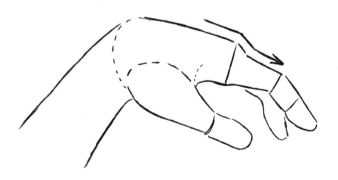

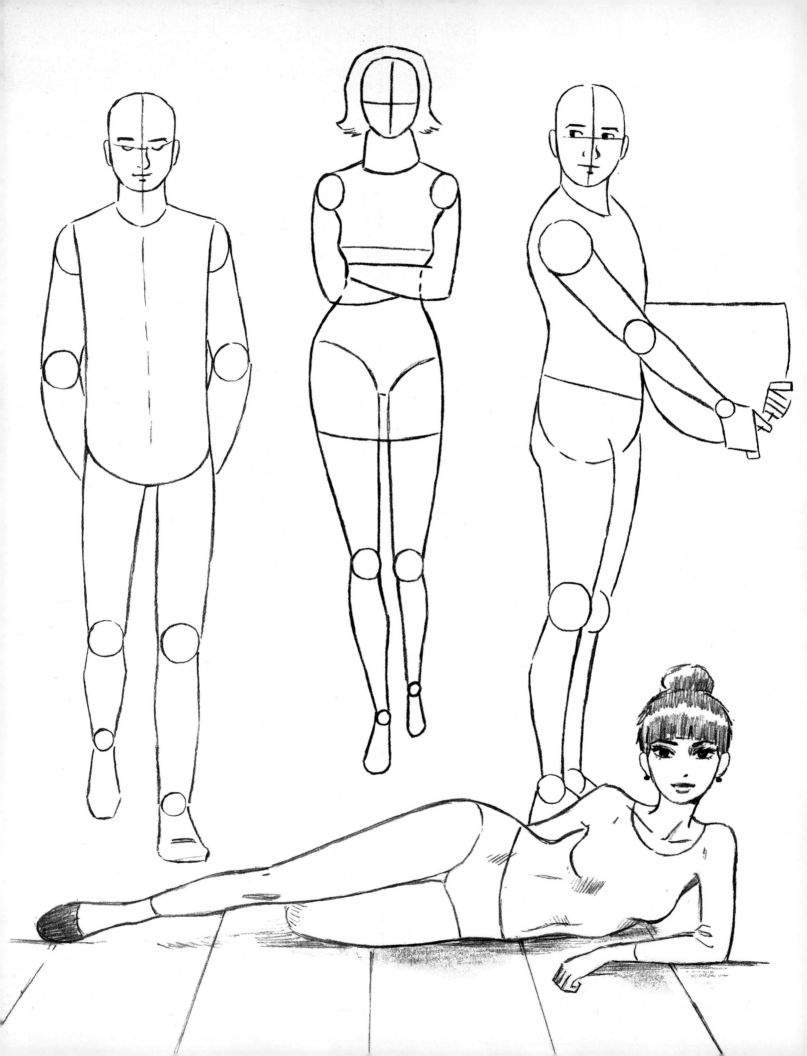

BEGIN TO DRAW
PEOPLE

Simple Techniques for Drawing the Head and Body

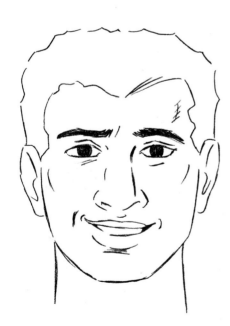
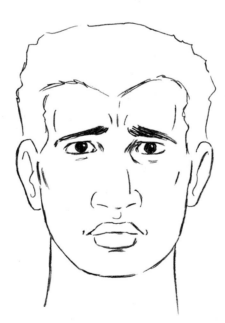
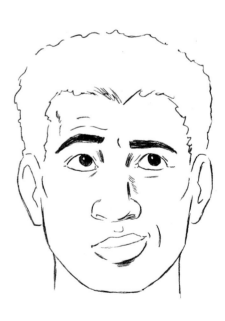

 Get Creative 6

New York

DRAWING WITH Christopher Hart

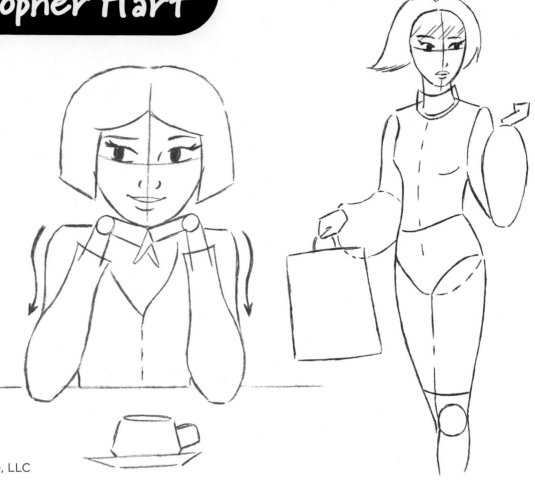

An imprint of **Get Creative 6**
104 West 27th Street
Third Floor
New York, NY 10001
sixthandspringbooks.com

Managing Editor
LAURA COOKE

Senior Editor
MICHELLE BREDESON

Art Director
IRENE LEDWITH

Chief Executive Officer
CAROLINE KILMER

President
ART JOINNIDES

Chairman
JAY STEIN

Library of Congress Cataloging-in-Publication Data
Names: Hart, Christopher, 1957- author.
Title: Begin to draw people : simple techniques for drawing the head and
 body / Christopher Hart.
Description: First edition. | New York, New York : Drawing with Christopher Hart, 2020.
Identifiers: LCCN 2019033999 | ISBN 9781684620005 (paperback)
Subjects: LCSH: Human figure in art--Juvenile literature. | Figure
 drawing--Technique--Juvenile literature.
Classification: LCC NC765 .H1868 2020 | DDC 743.4--dc23
LC record available at https://lccn.loc.gov/2019033999

Manufactured in China

3 5 7 9 10 8 6 4

First Edition

To my publishers
for all their
creative support

CONTENTS

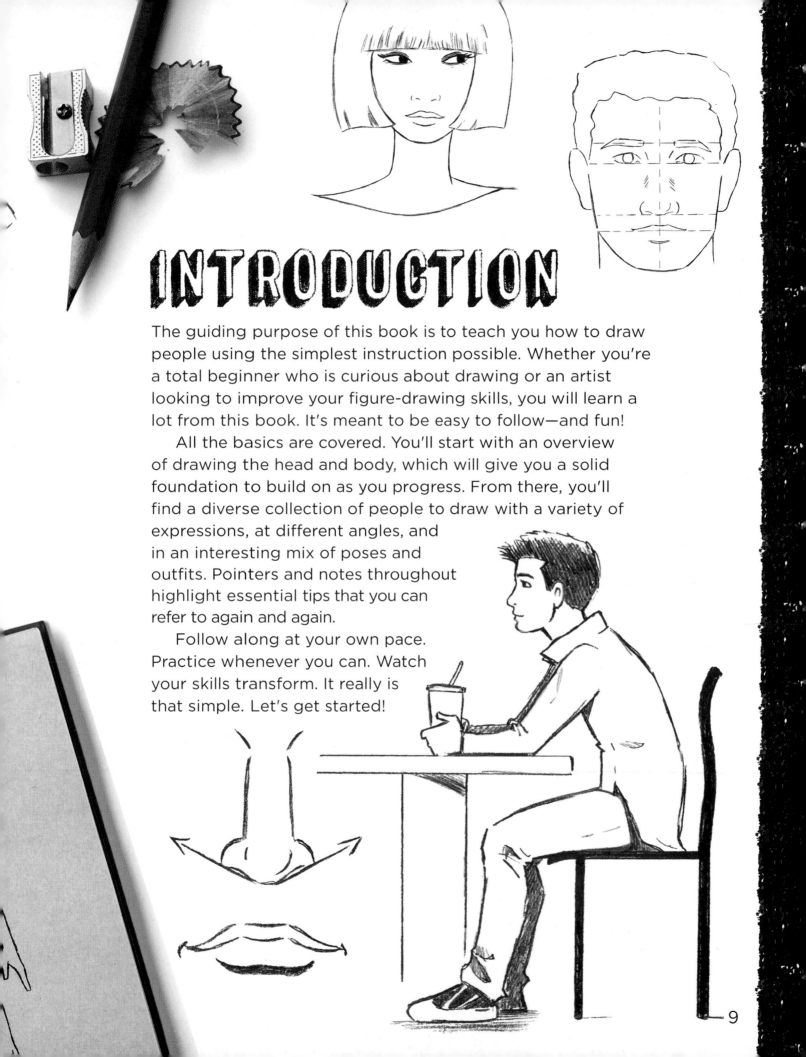

INTRODUCTION

The guiding purpose of this book is to teach you how to draw people using the simplest instruction possible. Whether you're a total beginner who is curious about drawing or an artist looking to improve your figure-drawing skills, you will learn a lot from this book. It's meant to be easy to follow—and fun!

All the basics are covered. You'll start with an overview of drawing the head and body, which will give you a solid foundation to build on as you progress. From there, you'll find a diverse collection of people to draw with a variety of expressions, at different angles, and in an interesting mix of poses and outfits. Pointers and notes throughout highlight essential tips that you can refer to again and again.

Follow along at your own pace. Practice whenever you can. Watch your skills transform. It really is that simple. Let's get started!

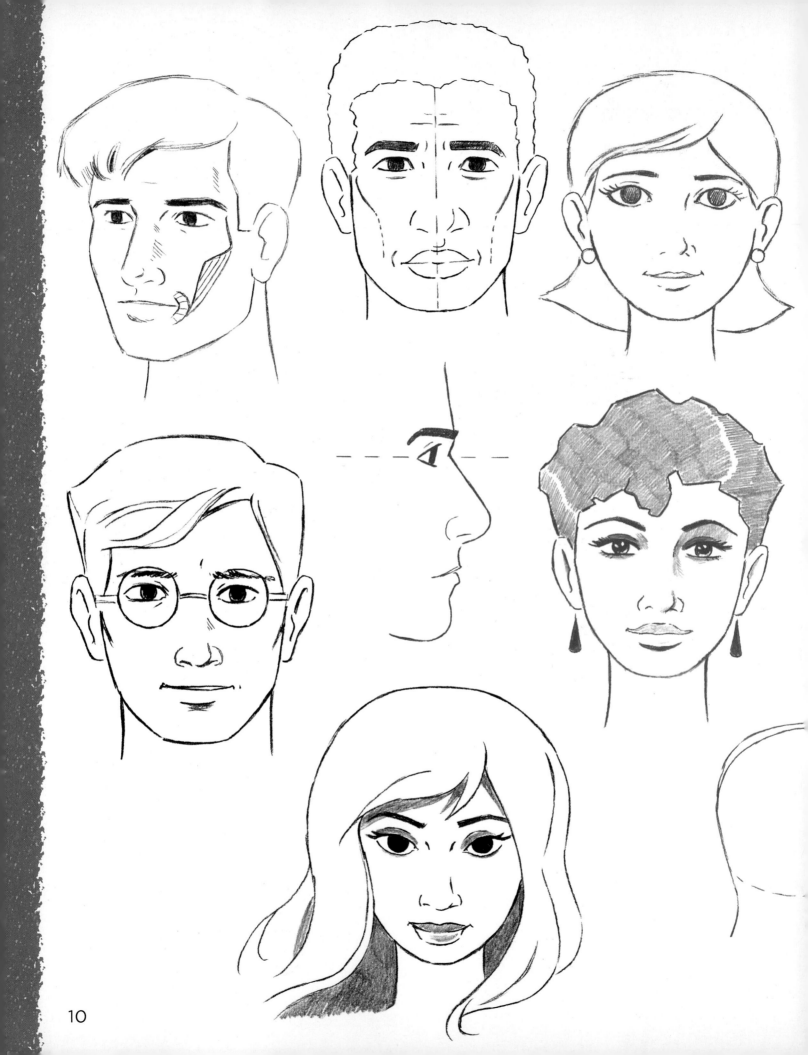

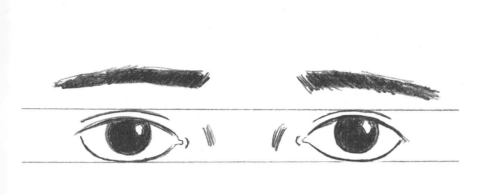

DRAWING THE HEAD—THE BASICS

I'd like you to start thinking in terms of drawing the *head* rather than the *face*. When we think of the face, we tend to visualize a flat surface, but the head has structure, depth, and dimension. Don't worry if you don't draw it perfectly on the first try. Drawing is a process. Look for small, steady improvements rather than big leaps in skill. And with that, let's dive right in!

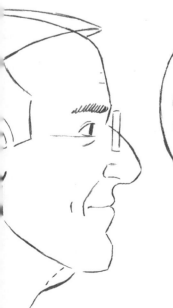

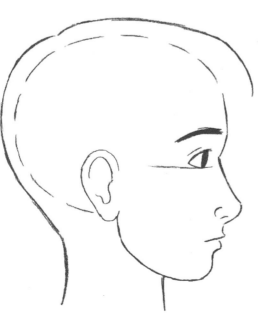

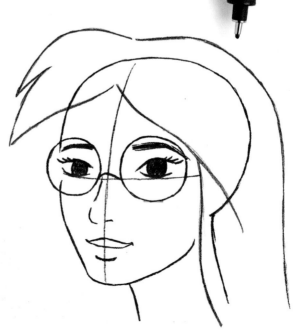

ESTABLISHING THE SHAPE OF THE HEAD

Here's one of the most important tips I can give you about drawing: Spend as much time working on the overall shape of the head as you do the features of the face. The outline of the head requires just as much care as the eyes do. And it will pay off in the way your drawings look.

Hidden Planes

The head only *appears* to be round. It's actually created with flat lines and curves, which are part of its hidden structure.

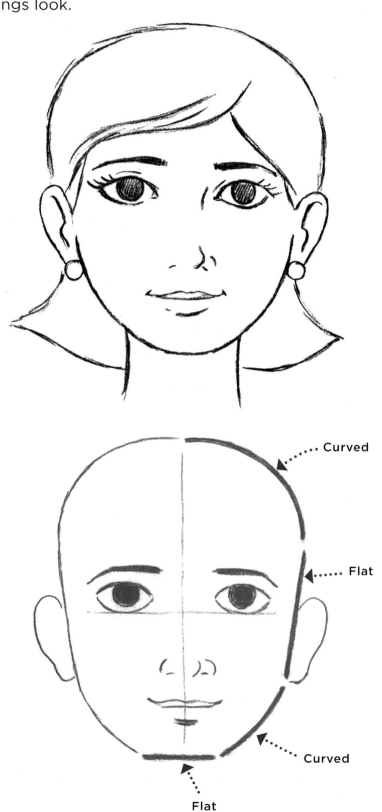

Curved

Flat

Curved

Flat

Keep It Simple

Maintaining a simple head construction allows us to draw the head in different directions and at different angles. Keeping it basic also helps us visualize the head as a solid shape.

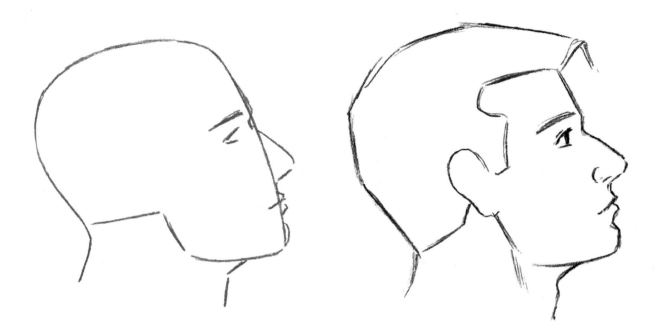

Underlying head shape—tilted up

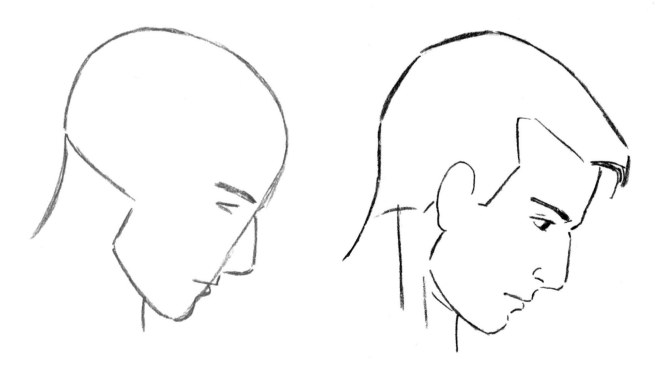

Underlying head shape—tilted down

CONTOURS OF THE HEAD

Don't worry—there's no need to memorize anatomy for this book. The purpose of this page is to illustrate an important concept: The contours of the head are determined by the muscles and bones underneath the skin. This gives a certain logic to its structure, which helps us as artists. No matter how different two faces may be, remember that they'll always have the same underlying structure.

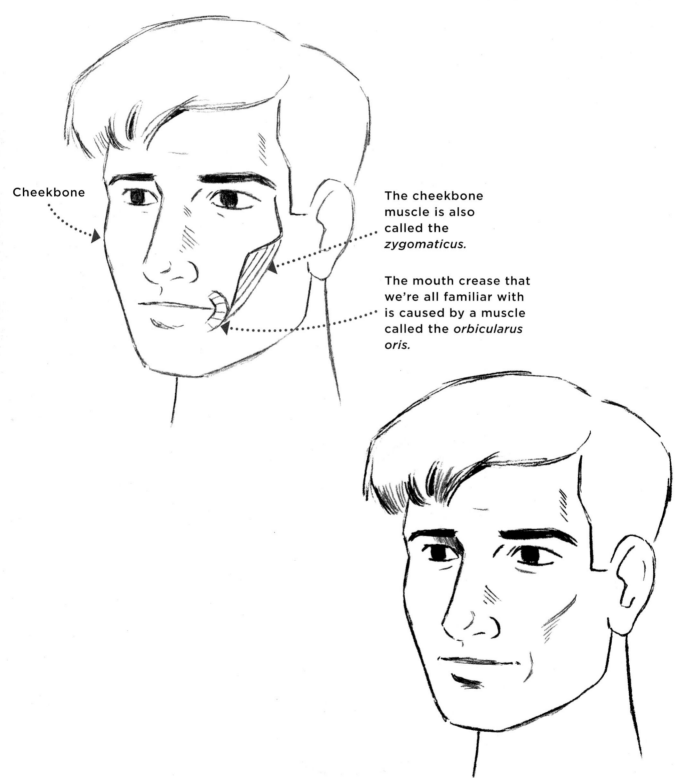

Cheekbone

The cheekbone muscle is also called the *zygomaticus.*

The mouth crease that we're all familiar with is caused by a muscle called the *orbicularus oris.*

WORKING WITH GUIDELINES

Head Shape Guidelines

The centerline (vertical) and eye line (horizontal) are drawn on most, if not all, of the faces in this book. They're helpful for keeping the eyebrows, nose, and mouth aligned.

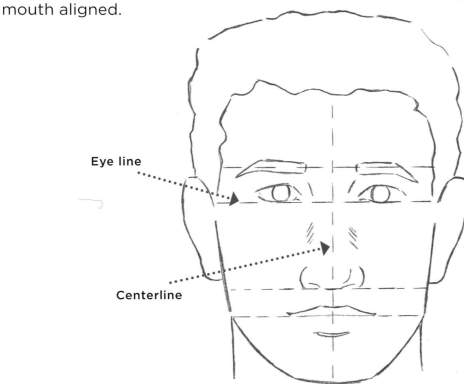

Eye line

Centerline

Use as many guidelines as you find helpful. I've added additional guidelines across the eyebrows and between the nose and mouth.

DRAWING THE FEATURES

No two people have features that look exactly the same, but these templates will give you a good basis upon which to begin.

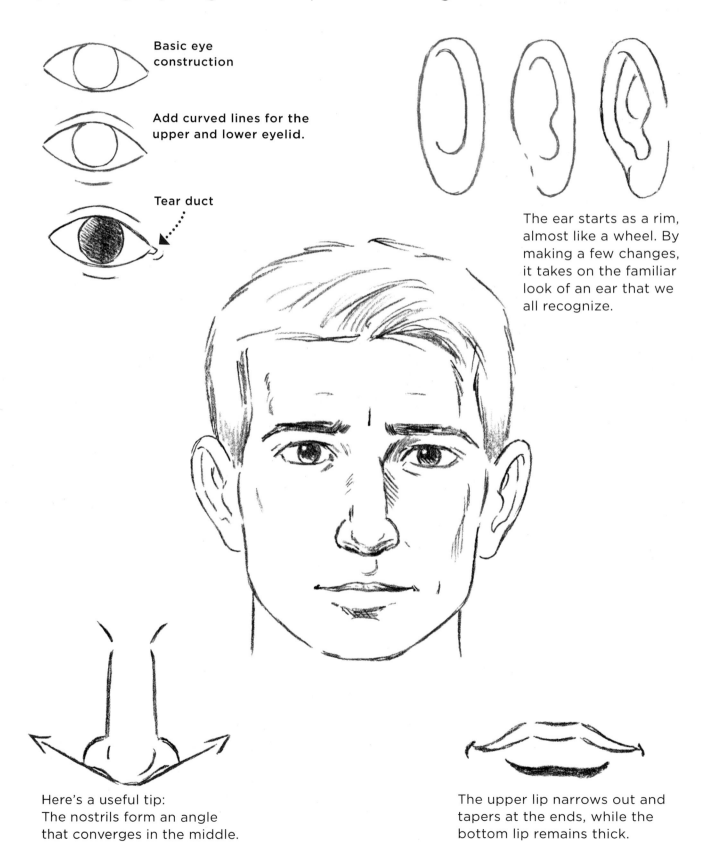

Basic eye construction

Add curved lines for the upper and lower eyelid.

Tear duct

The ear starts as a rim, almost like a wheel. By making a few changes, it takes on the familiar look of an ear that we all recognize.

Here's a useful tip: The nostrils form an angle that converges in the middle.

The upper lip narrows out and tapers at the ends, while the bottom lip remains thick.

TWO TIPS FOR DRAWING EYES

Learning these two tips can dramatically improve your ability to draw the eyes. The surprising thing is that they're not about the shape of the eyes, but about the placement (their position relative to each other).

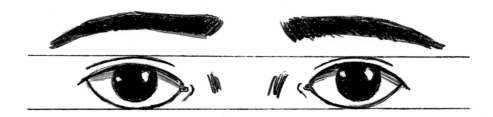

1 I've shown you the technique of drawing a horizontal guideline under the eyes to maintain an even look. But if you're still having trouble, try drawing a second horizontal guideline above the eyes. This will help you keep both eyes the same size.

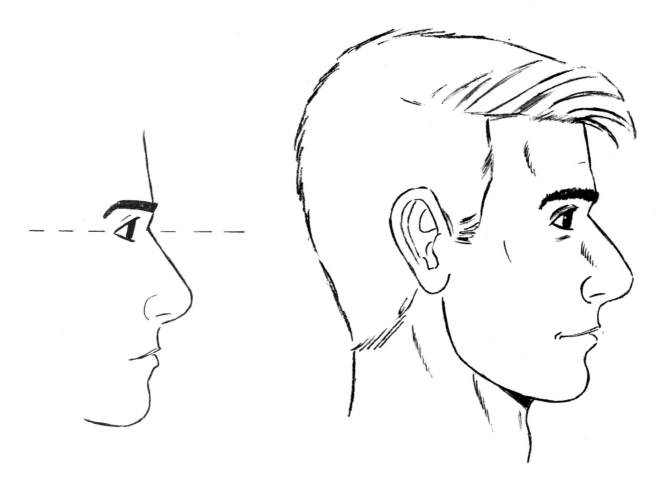

2 The eyes are drawn at the indentation at the bridge of the nose. Now that you know, you'll no longer have to experiment with its placement!

DRAWING THE NOSE IN FOUR EASY STEPS

Let's start with a blank slate so that you can see how the nose comes together, step by step. When followed in order, these steps make drawing this feature easy and instinctive.

Sketch the bottom of the nose to establish its length (how far down the face it goes).

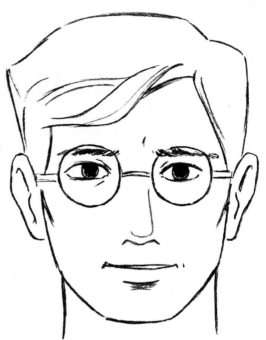

Draw the bridge of the nose. (Emphasize one side.)

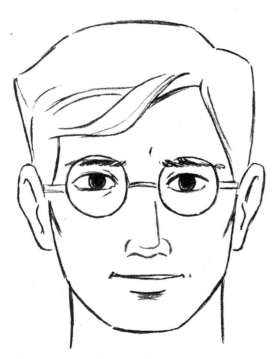

Draw both "covers" over the nostrils.

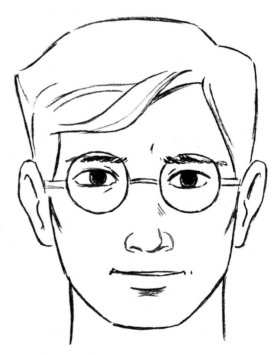

For the final image, add detail such as shading. You can also omit detail, like eliminating some of the definition of the bridge of the nose, as I've done here.

ADDING TONE TO THE HAIR

Shading the hair can seem like a subjective process in which you simply add tone wherever you want, but there's logic to it. Here are some key points to use for shading hair. You can decide how you want to apply these techniques.

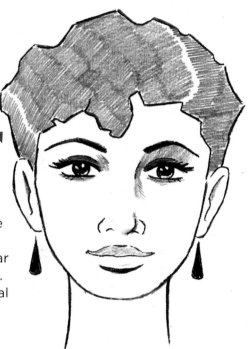

Line Only
This unshaded approach emphasizes line quality rather than tone.

Single Tone
This approach uses a single tone for the hair. Slight white areas naturally appear between the pencil strokes. These give the hair a natural look.

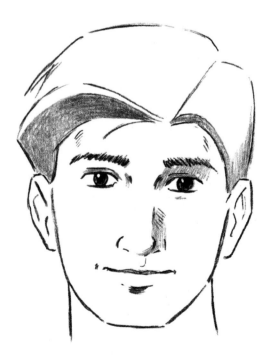

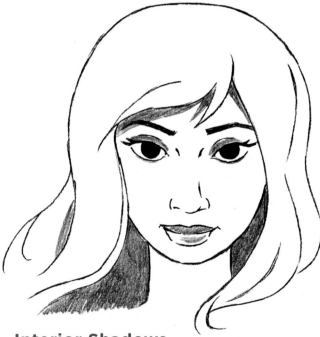

Adding Shadow
The hair can be divided into different planes along the head. Here, by shading the front plane of the hair but not the top plane, you create the look of depth.

Interior Shadows
Long hair is like a cape that leaves pockets of space between it and the head and neck. By filling in those pockets with shadow, you make the head look three-dimensional.

HAIRSTYLES

Use the popular hairstyles on these pages as starting points for drawing hair. You'll see many more examples of hairstyles as you make your way through this book.

Women's Hairstyles

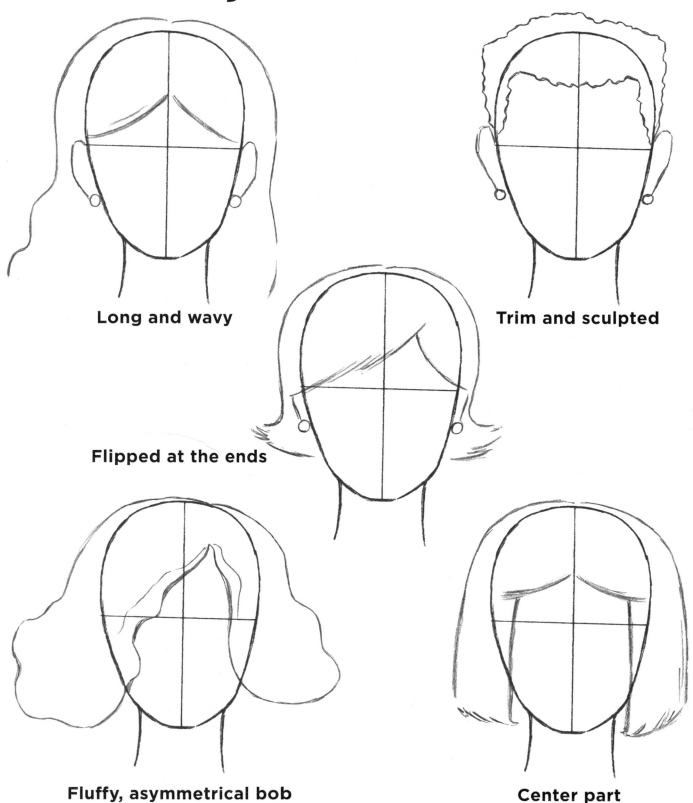

Long and wavy

Trim and sculpted

Flipped at the ends

Fluffy, asymmetrical bob

Center part

Men's Hairstyles

Combed back, medium

Combed back, short

Spiked to one side

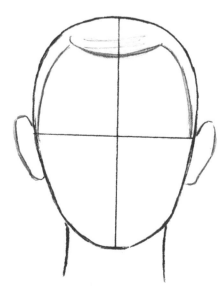

Receding hairline

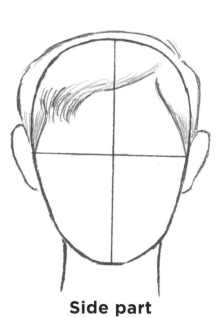

Side part

HOW TO SHOW DIFFERENT AGES

The shape and size of the head and features can be adjusted to suggest specific age groups. If you want to draw a kid playing with his dad, the child's face will require different proportions than his father's. You'll probably sense some of these concepts intuitively, but seeing them demonstrated helps to lock them in.

AGE: Child

One of the first impressions you get of a child's head is that the back of the head is large and the neck is slender. Let's turn to the individual contours and features.

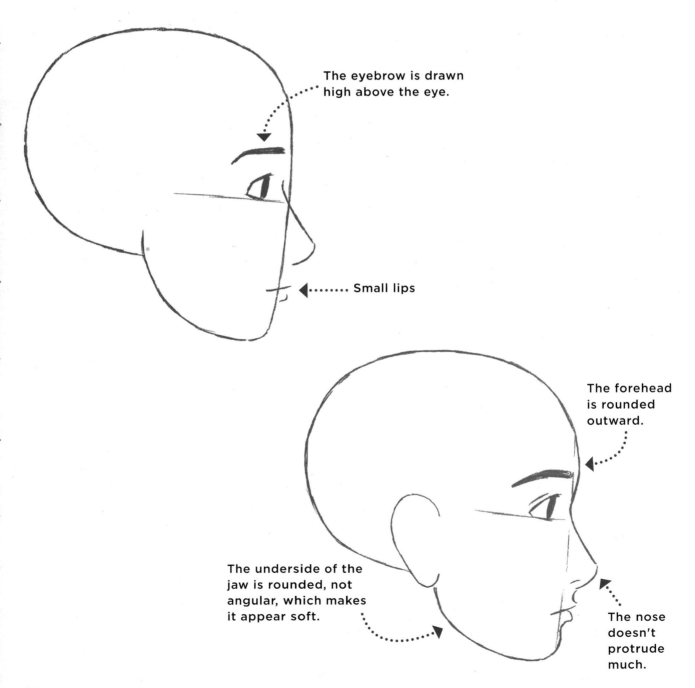

The eyebrow is drawn high above the eye.

Small lips

The forehead is rounded outward.

The underside of the jaw is rounded, not angular, which makes it appear soft.

The nose doesn't protrude much.

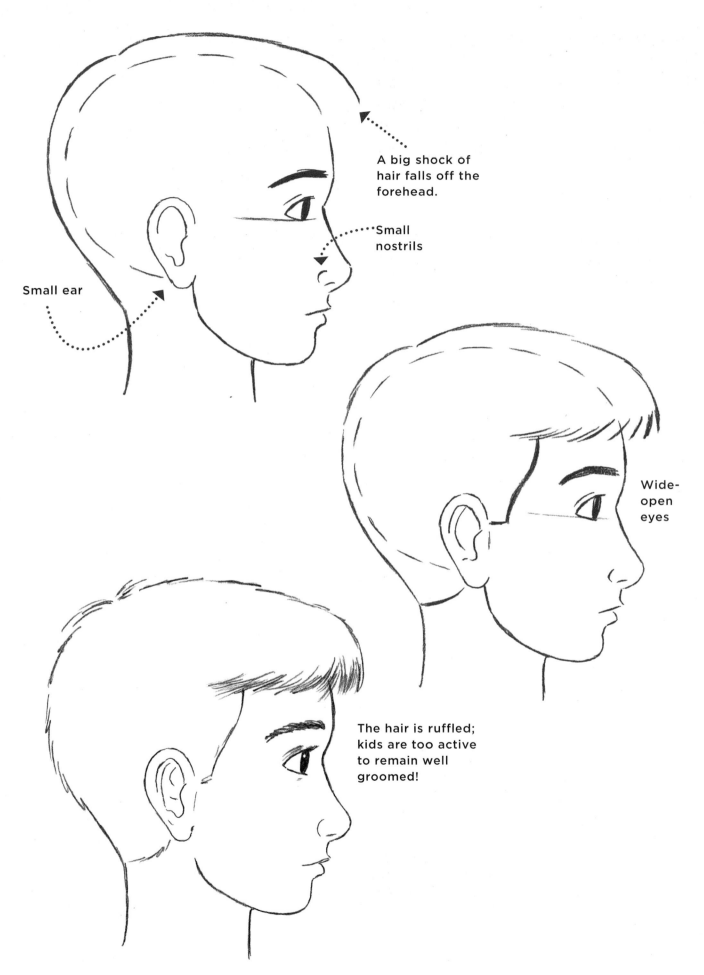

A big shock of hair falls off the forehead.

Small nostrils

Small ear

Wide-open eyes

The hair is ruffled; kids are too active to remain well groomed!

AGE: Teenager

As a child grows into her or his teenage years, the face lengthens and the back of the head loses its oversized, rounded look. The features are in more balanced proportion: None are oversized (for example, the eyes) or undersized (for example, the chin).

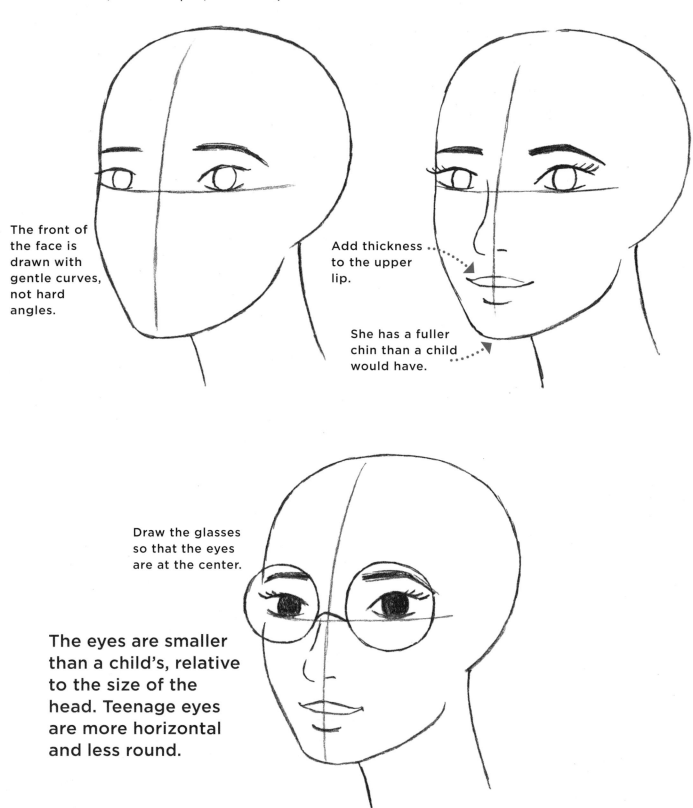

The front of the face is drawn with gentle curves, not hard angles.

Add thickness to the upper lip.

She has a fuller chin than a child would have.

Draw the glasses so that the eyes are at the center.

The eyes are smaller than a child's, relative to the size of the head. Teenage eyes are more horizontal and less round.

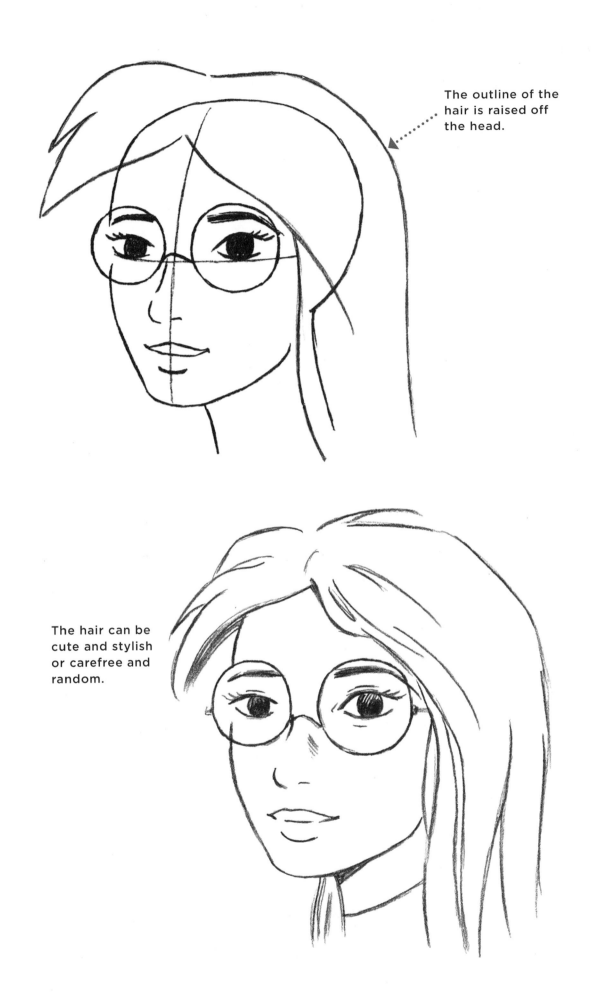

The outline of the
hair is raised off
the head.

The hair can be
cute and stylish
or carefree and
random.

AGE: Adult

The jump from teenager to adult comes with a big shift in appearance. The face becomes fuller and the bones get heavier and more angular. The nose gains more prominence, especially for males. For females, the eyelashes are longer and the eyebrows are arched slightly higher.

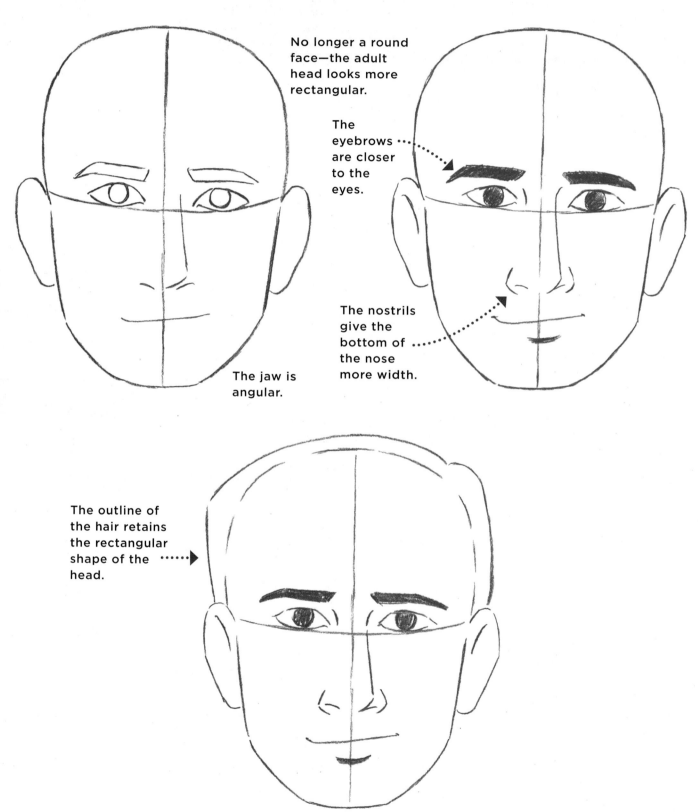

No longer a round face—the adult head looks more rectangular.

The eyebrows are closer to the eyes.

The nostrils give the bottom of the nose more width.

The jaw is angular.

The outline of the hair retains the rectangular shape of the head.

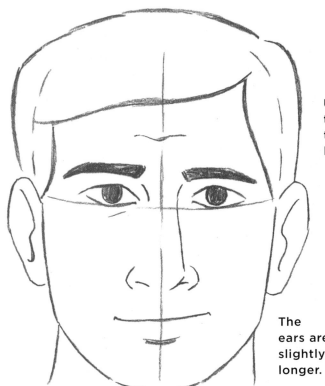

Unlike hard-to-tame teenage hair, the typical adult hairstyle looks controlled.

The ears are slightly longer.

The neck is slightly wider than a teen's neck.

There's a misconception that adults are more difficult to draw than kids and teens. Actually, adults may be easier because the head shape is more clearly defined, which makes the placement of the features easier to locate.

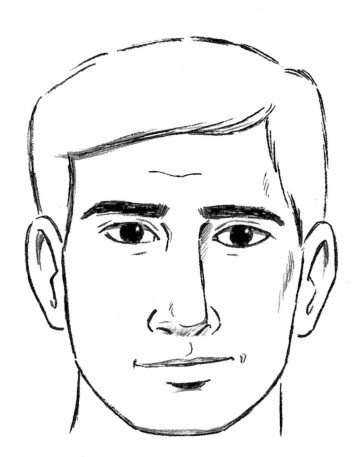

AGE: Senior Citizen

In older people, the overall look of the head and neck is thicker. In profile, we see that the nose, mouth, and chin are more angular and pronounced. This creates the look that grandkids love so much!

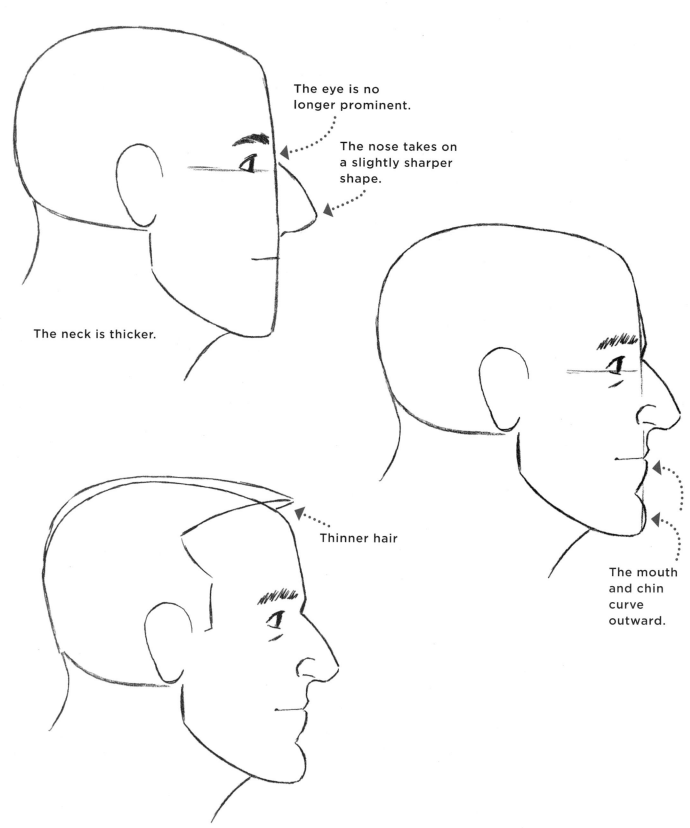

The eye is no longer prominent.

The nose takes on a slightly sharper shape.

The neck is thicker.

Thinner hair

The mouth and chin curve outward.

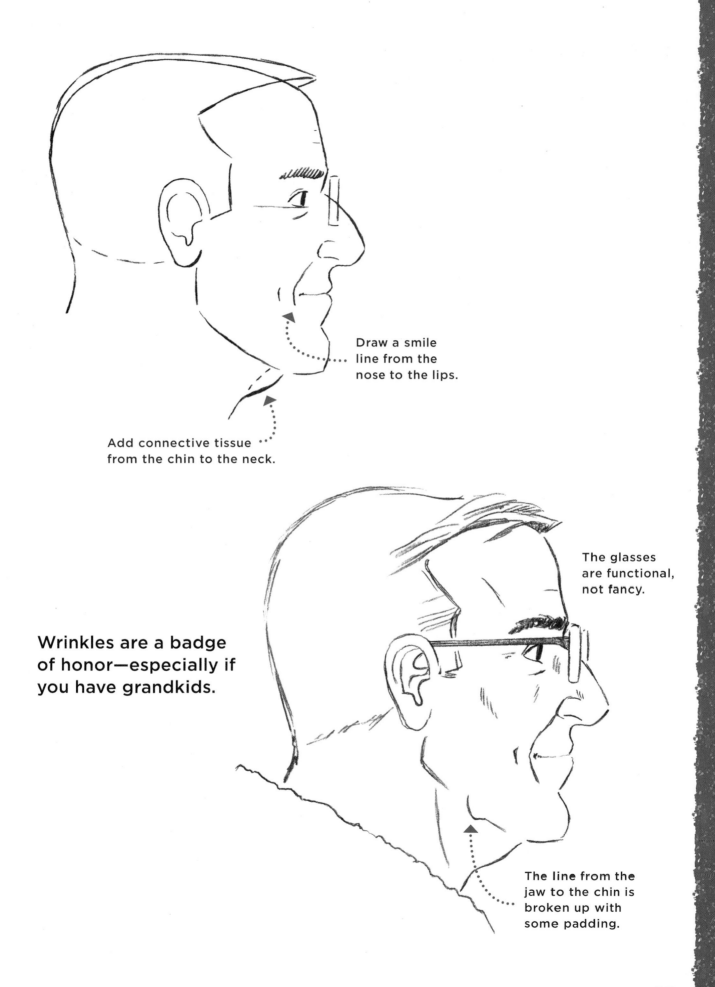

Draw a smile line from the nose to the lips.

Add connective tissue from the chin to the neck.

The glasses are functional, not fancy.

Wrinkles are a badge of honor—especially if you have grandkids.

The line from the jaw to the chin is broken up with some padding.

DRAWING EXPRESSIONS

When a person is happy, the bottom eyelids push upward. When a person is angry, the eyebrows press down. Lips can tug left or right. With a few simple techniques, you can arrange the facial features to suggest emotions and even thoughts.

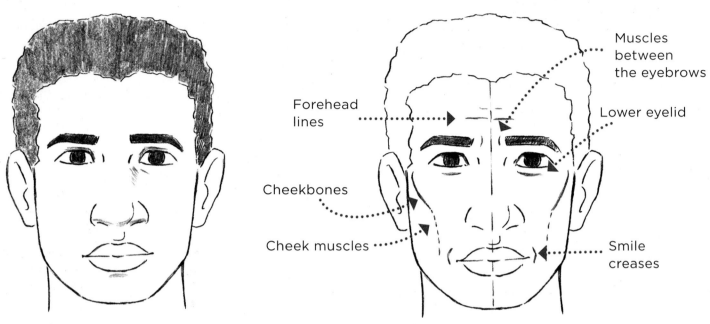

The Relaxed Face
With no defined muscles in the form of creases or wrinkles, the face appears relaxed and expressionless.

Underlying Dynamics
A few simple details show the underlying muscles of the face, which work together to create an expression.

Forehead lines

Muscles between the eyebrows

Lower eyelid

Cheekbones

Cheek muscles

Smile creases

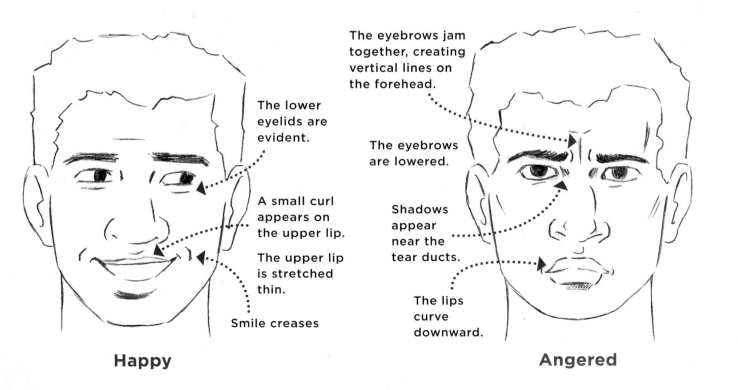

The lower eyelids are evident.

A small curl appears on the upper lip.

The upper lip is stretched thin.

Smile creases

The eyebrows jam together, creating vertical lines on the forehead.

The eyebrows are lowered.

Shadows appear near the tear ducts.

The lips curve downward.

Happy

Angered

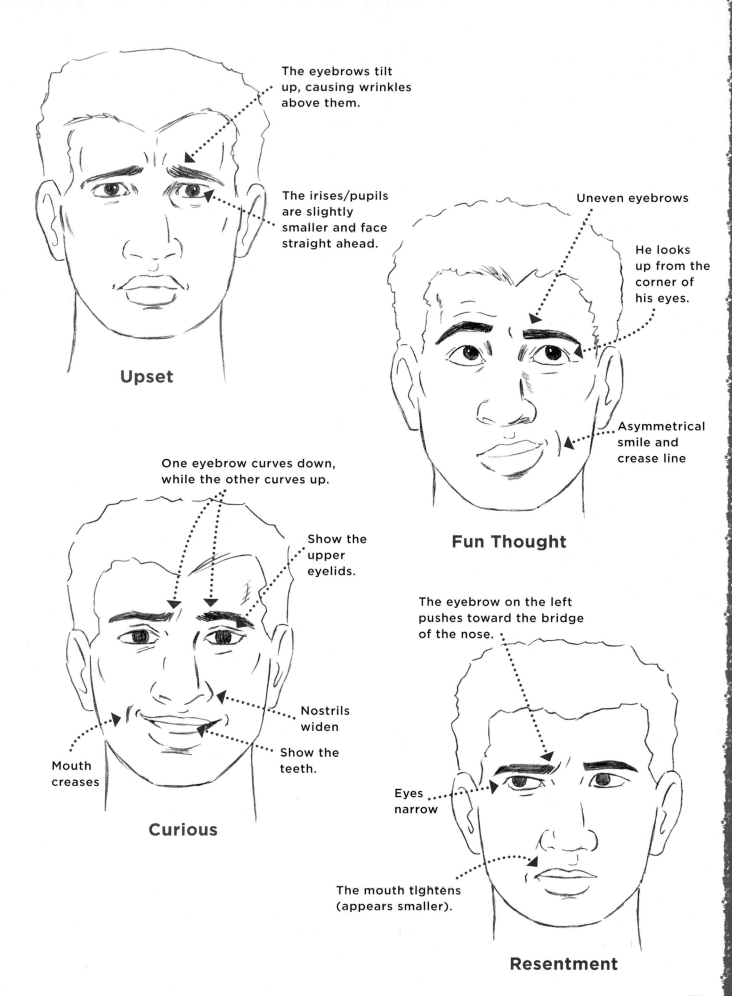

The eyebrows tilt up, causing wrinkles above them.

The irises/pupils are slightly smaller and face straight ahead.

Upset

Uneven eyebrows

He looks up from the corner of his eyes.

Asymmetrical smile and crease line

Fun Thought

One eyebrow curves down, while the other curves up.

Show the upper eyelids.

Nostrils widen

Show the teeth.

Mouth creases

Curious

The eyebrow on the left pushes toward the bridge of the nose.

Eyes narrow

The mouth tightens (appears smaller).

Resentment

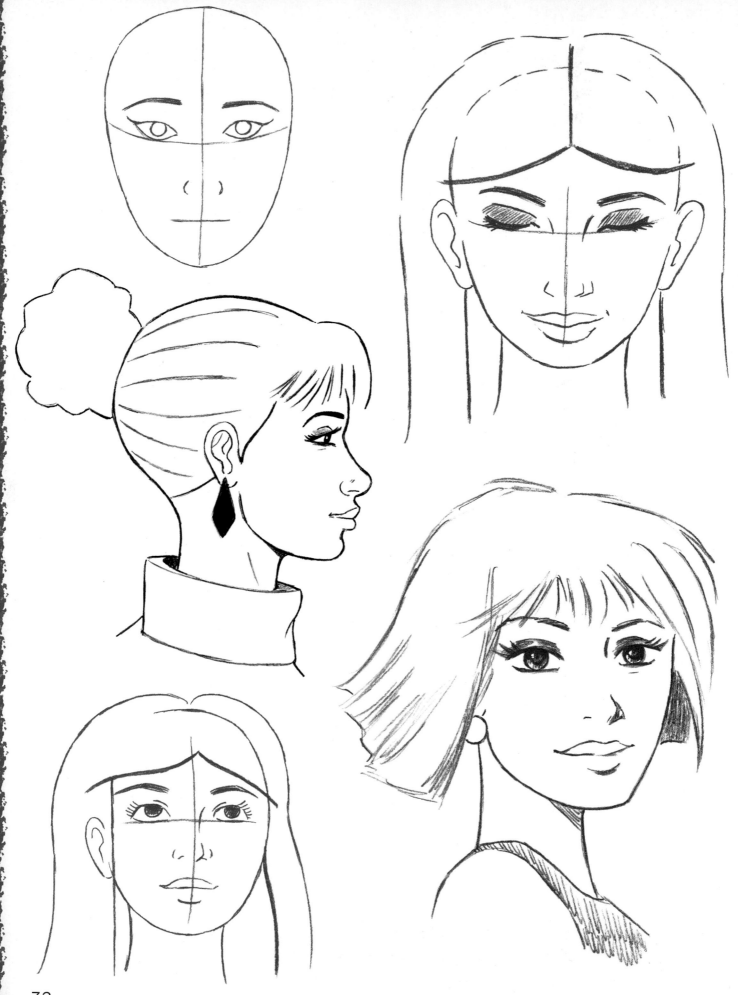

DRAWING FEMALE FACES

Now that we've familiarized ourselves with some of the basic concepts for drawing the head, let's start drawing step by step. This chapter will cover women, and the next chapter will cover—you guessed it—men. I've included different hairstyles, expressions, ages, and angles. Using variety in your work is a great way to see the concepts in action.

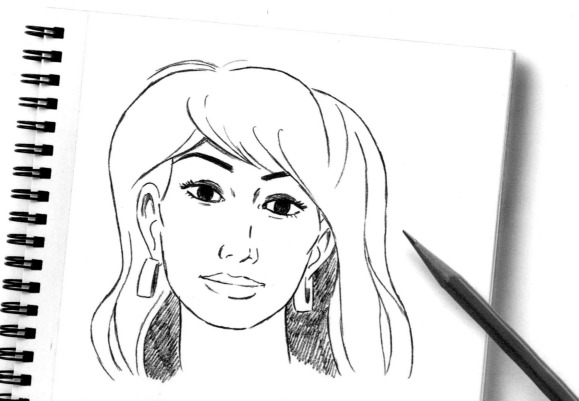

BIG SMILE

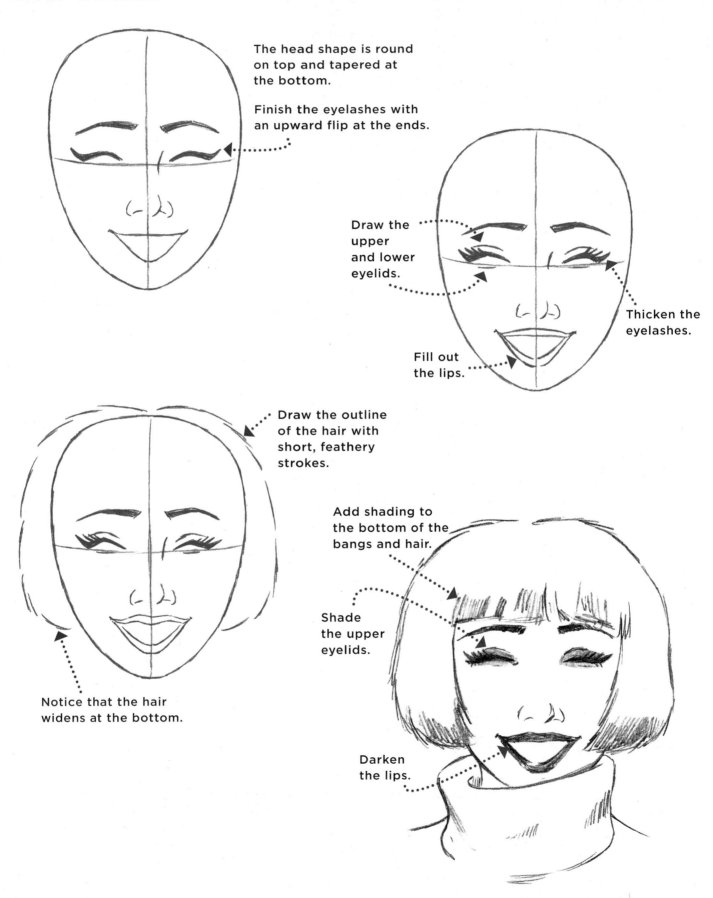

The head shape is round on top and tapered at the bottom.

Finish the eyelashes with an upward flip at the ends.

Draw the upper and lower eyelids.

Thicken the eyelashes.

Fill out the lips.

Draw the outline of the hair with short, feathery strokes.

Add shading to the bottom of the bangs and hair.

Shade the upper eyelids.

Notice that the hair widens at the bottom.

Darken the lips.

PRETEEN GIRL

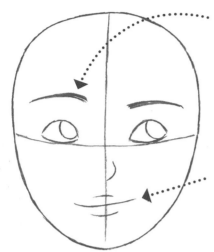

Draw the eyebrow on the left slightly higher than the one on the right, for a fun expression.

Lift her mouth slightly on the right side.

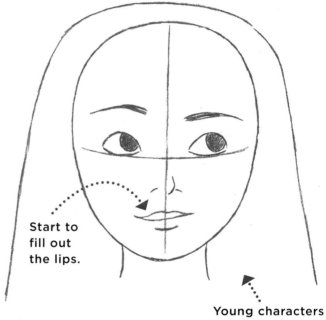

Start to fill out the lips.

Young characters have a lot of hair.

Fringed bangs go down to the eyebrows.

Draw straight lines for the interior of the hair.

When someone looks up and to the side, they look like they've got an idea.

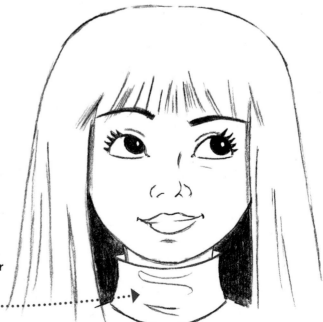

Make the collar a turtleneck.

WOMAN IN HER TWENTIES

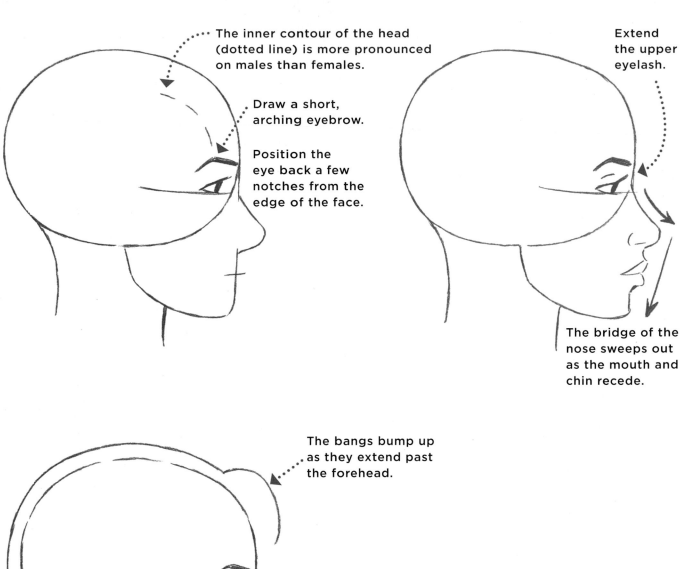

The inner contour of the head (dotted line) is more pronounced on males than females.

Draw a short, arching eyebrow.

Position the eye back a few notches from the edge of the face.

Extend the upper eyelash.

The bridge of the nose sweeps out as the mouth and chin recede.

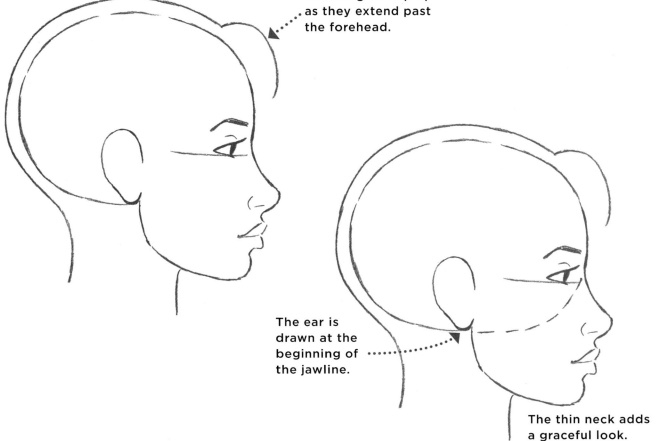

The bangs bump up as they extend past the forehead.

The ear is drawn at the beginning of the jawline.

The thin neck adds a graceful look.

Pouf out the hair above the head.

The back of the head gently flows into the back of the neck.

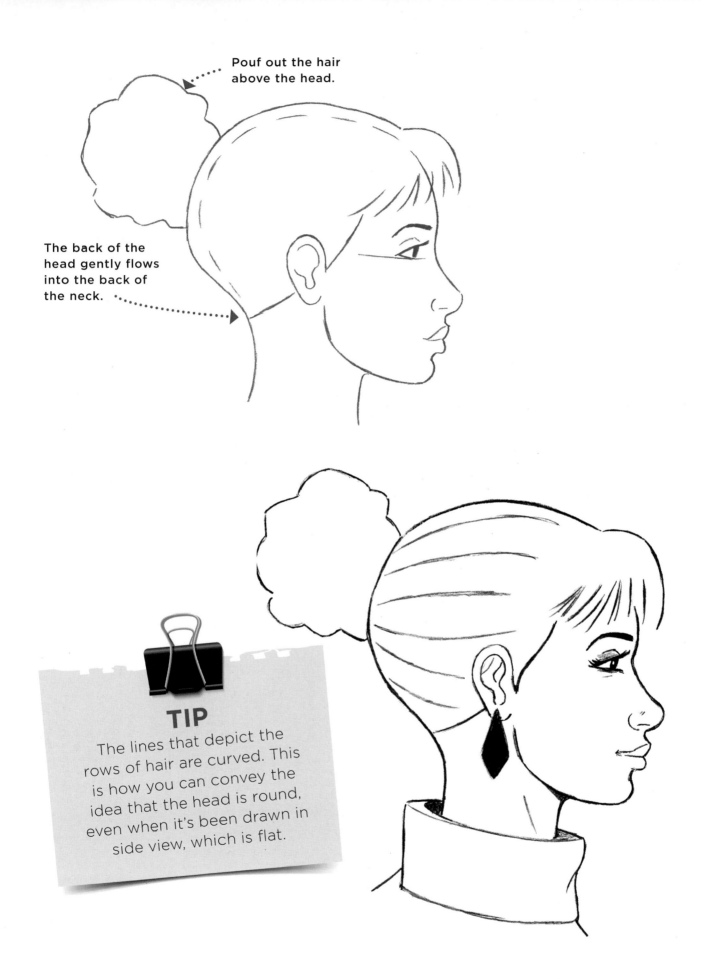

TIP
The lines that depict the rows of hair are curved. This is how you can convey the idea that the head is round, even when it's been drawn in side view, which is flat.

PLEASANT DISPOSITION

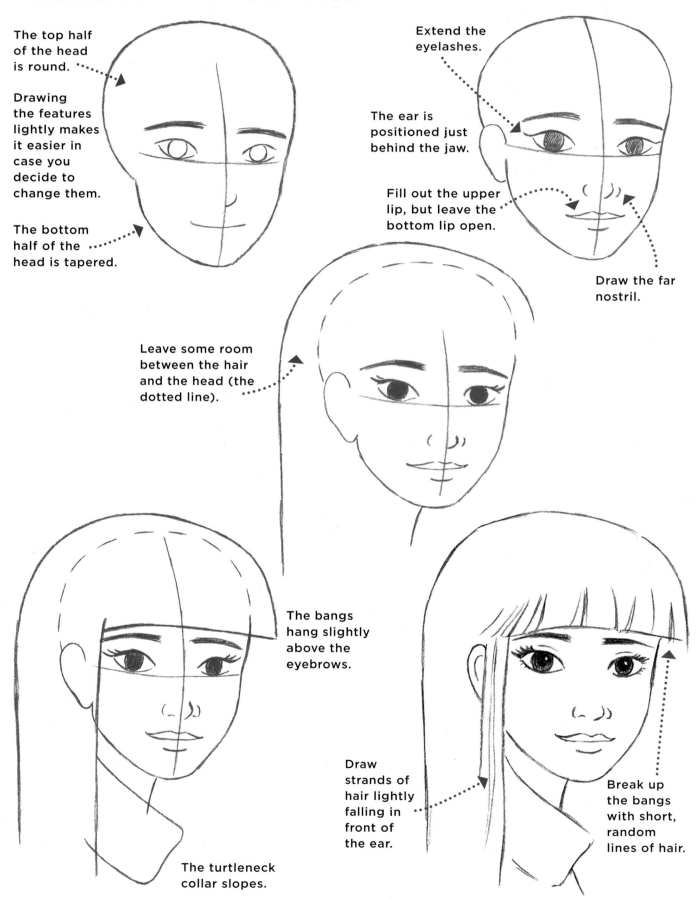

The top half of the head is round.

Drawing the features lightly makes it easier in case you decide to change them.

The bottom half of the head is tapered.

Extend the eyelashes.

The ear is positioned just behind the jaw.

Fill out the upper lip, but leave the bottom lip open.

Draw the far nostril.

Leave some room between the hair and the head (the dotted line).

The bangs hang slightly above the eyebrows.

Draw strands of hair lightly falling in front of the ear.

The turtleneck collar slopes.

Break up the bangs with short, random lines of hair.

ATTRACTIVE EYES

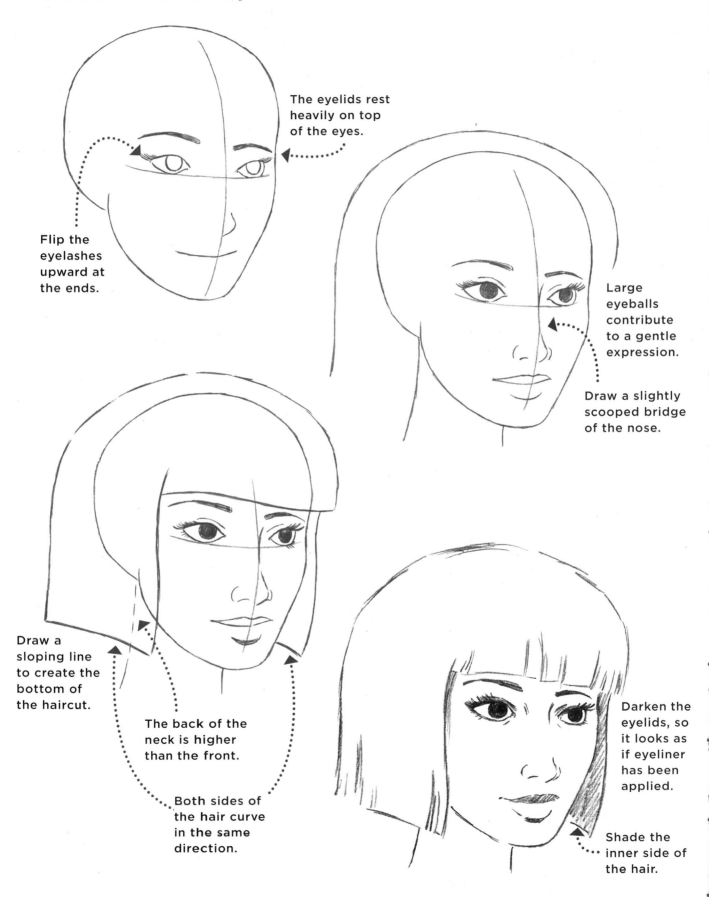

The eyelids rest heavily on top of the eyes.

Flip the eyelashes upward at the ends.

Large eyeballs contribute to a gentle expression.

Draw a slightly scooped bridge of the nose.

Draw a sloping line to create the bottom of the haircut.

The back of the neck is higher than the front.

Both sides of the hair curve in the same direction.

Darken the eyelids, so it looks as if eyeliner has been applied.

Shade the inner side of the hair.

DOWNWARD GLANCE

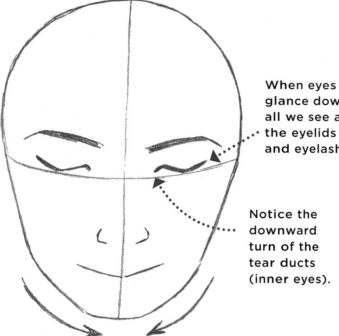

When eyes glance down, all we see are the eyelids and eyelashes.

Notice the downward turn of the tear ducts (inner eyes).

The jawline is tapered.

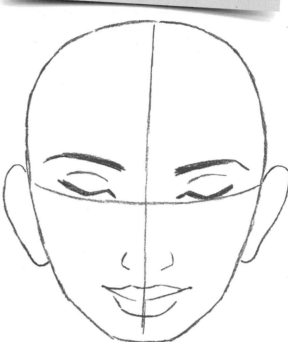

Let's check some proportions

 Are the eyebrows close enough to the eyes?

 Is the centerline (the vertical guideline) running down the middle of the lips?

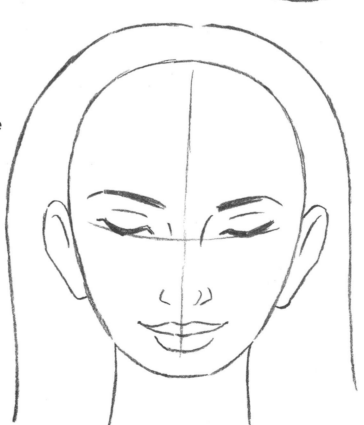

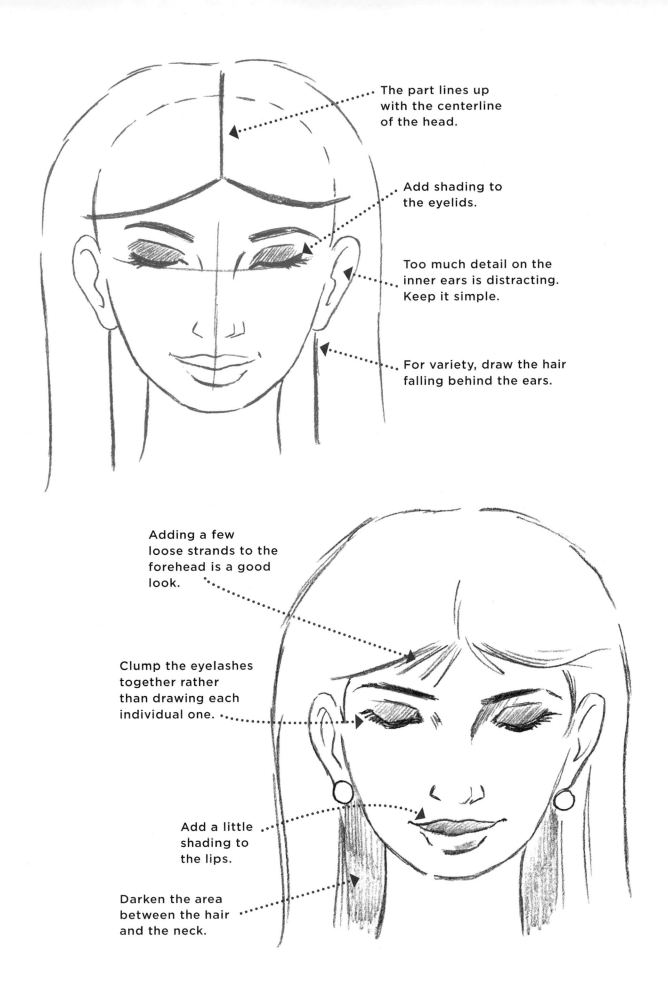

The part lines up with the centerline of the head.

Add shading to the eyelids.

Too much detail on the inner ears is distracting. Keep it simple.

For variety, draw the hair falling behind the ears.

Adding a few loose strands to the forehead is a good look.

Clump the eyelashes together rather than drawing each individual one.

Add a little shading to the lips.

Darken the area between the hair and the neck.

LOOKING TOWARD THE FUTURE

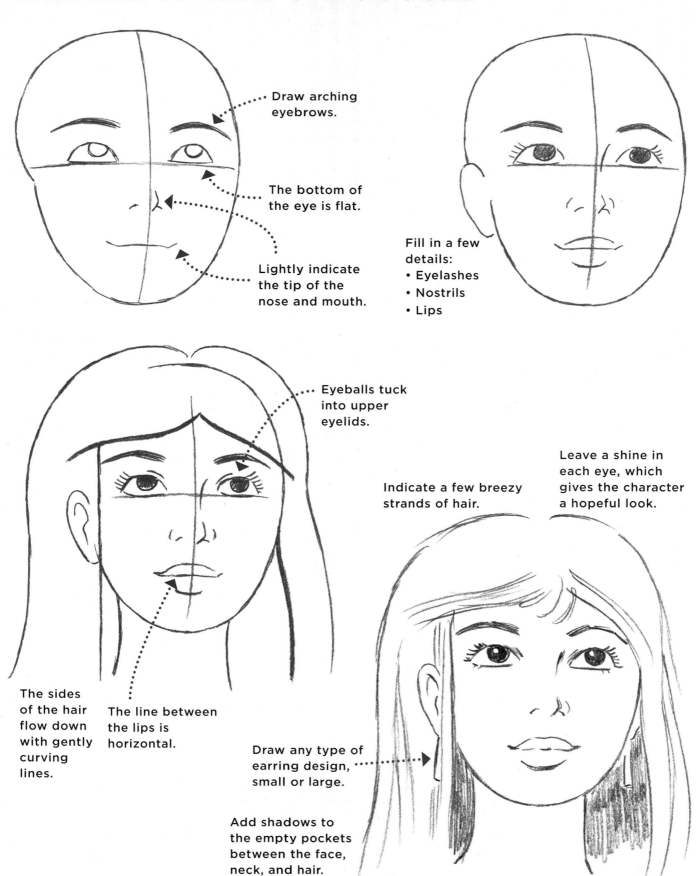

Draw arching eyebrows.

The bottom of the eye is flat.

Lightly indicate the tip of the nose and mouth.

Fill in a few details:
• Eyelashes
• Nostrils
• Lips

Eyeballs tuck into upper eyelids.

Indicate a few breezy strands of hair.

Leave a shine in each eye, which gives the character a hopeful look.

The sides of the hair flow down with gently curving lines.

The line between the lips is horizontal.

Draw any type of earring design, small or large.

Add shadows to the empty pockets between the face, neck, and hair.

STYLISH HAIRCUT

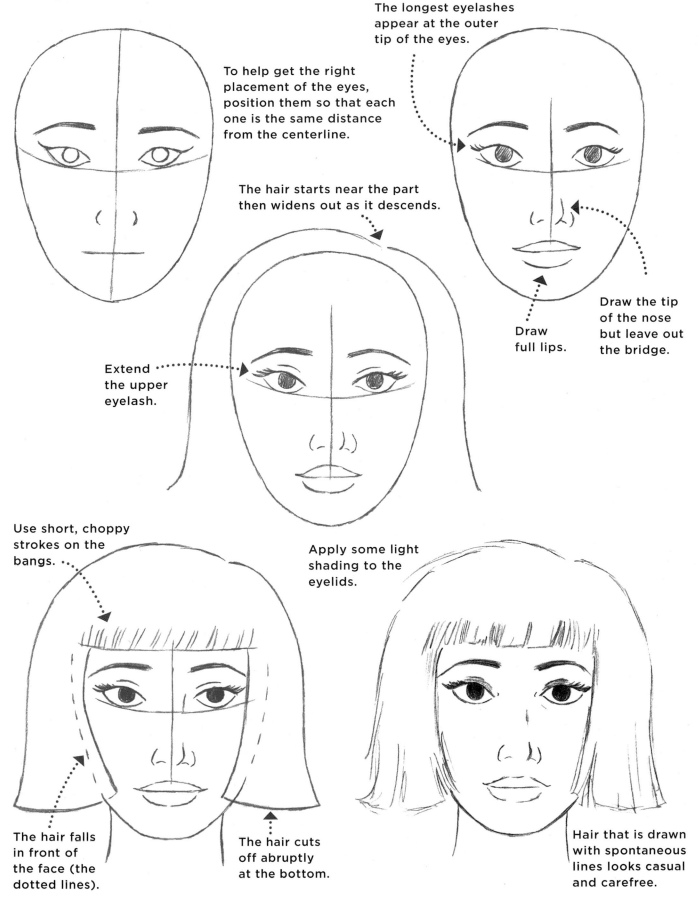

The longest eyelashes appear at the outer tip of the eyes.

To help get the right placement of the eyes, position them so that each one is the same distance from the centerline.

The hair starts near the part then widens out as it descends.

Draw the tip of the nose but leave out the bridge.

Draw full lips.

Extend the upper eyelash.

Use short, choppy strokes on the bangs.

Apply some light shading to the eyelids.

The hair falls in front of the face (the dotted lines).

The hair cuts off abruptly at the bottom.

Hair that is drawn with spontaneous lines looks casual and carefree.

APPEALING SMILE

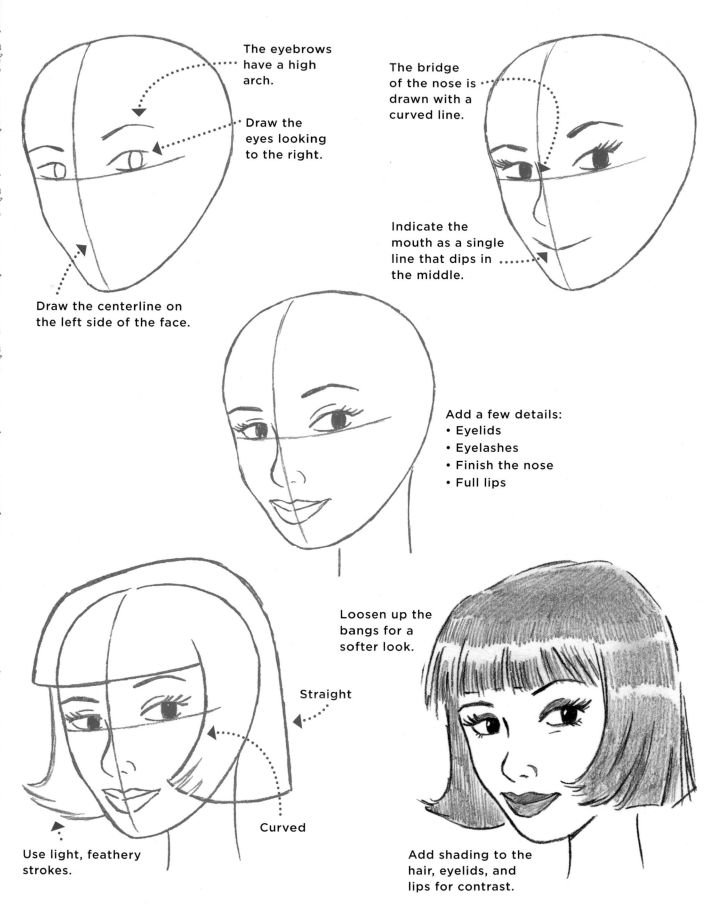

The eyebrows have a high arch.

Draw the eyes looking to the right.

Draw the centerline on the left side of the face.

The bridge of the nose is drawn with a curved line.

Indicate the mouth as a single line that dips in the middle.

Add a few details:
• Eyelids
• Eyelashes
• Finish the nose
• Full lips

Loosen up the bangs for a softer look.

Straight

Curved

Use light, feathery strokes.

Add shading to the hair, eyelids, and lips for contrast.

BREEZY LOOK

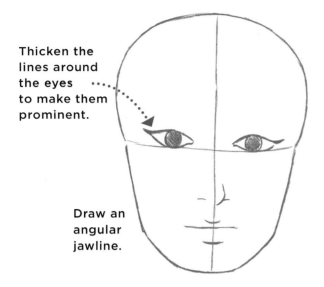

Thicken the lines around the eyes to make them prominent.

Draw an angular jawline.

Lift the eyebrows in a big arch.

Show eyelid creases just above the eyes.

The lips are slightly oversized.

Draw flowing hair with a part on the left side.

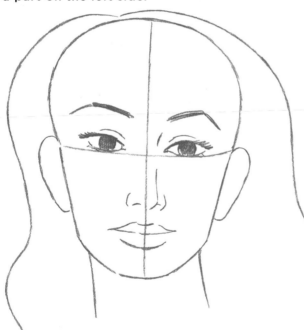

Let's check the ear placement

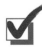 Are the ears approximately the same size?

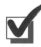 Are the ears at the same level as the nose?

Add shading to the eyelids and to the interior of the haircut.

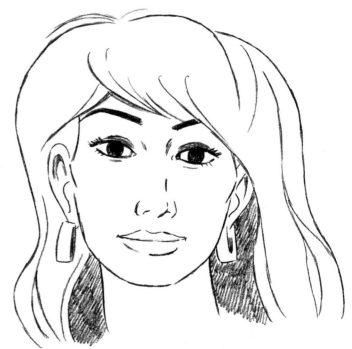

Draw multiple strands of hair throughout the haircut. The more the strands appear to flow, the breezier the hairstyle will be.

BUSINESS LEADER

The centerline indicates that the character is facing right.

The head is less round and more vertical.

Square off the bottom of the chin.

Indicate the entire bridge of the nose for placement, even if you end up omitting some of it later. (See dotted line.)

Vary the size of the curls.

The hair dips over the forehead.

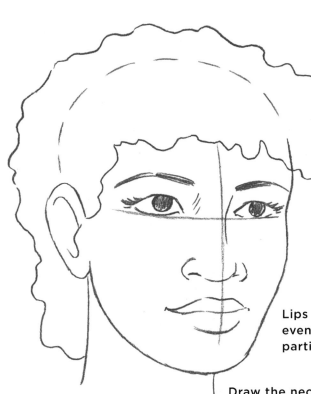

TIP
I like to draw leaders with a confident look. This is created by focusing the eyes straight ahead on something in the distance.

Lips are drawn with curves even when they don't show a particular expression.

Draw the neck straight.

Make It Your Own

You can choose to draw more curls inside the outline of the hair to add more detail. It's not necessary, as the outline already implies it, but feel free to experiment to get the look you want.

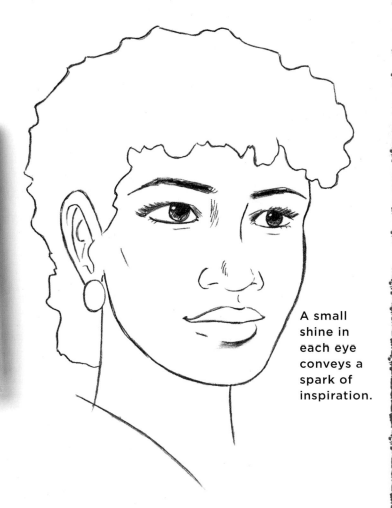

A small shine in each eye conveys a spark of inspiration.

SKEPTICAL EXPRESSION

Draw an oval shape, but don't taper it too much at the bottom.

She's somewhat skeptical, so narrow the eyes.

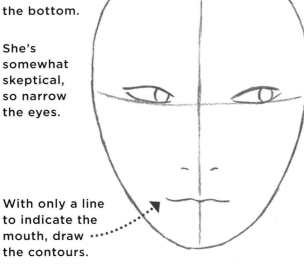

With only a line to indicate the mouth, draw the contours.

PROPORTION HINT

You should be able to fit one eye between the two eyes.

Complete the eyes with eyelashes and crease lines above the eyelids.

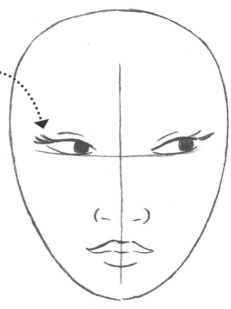

Begin a wide haircut with the centerline serving as the part.

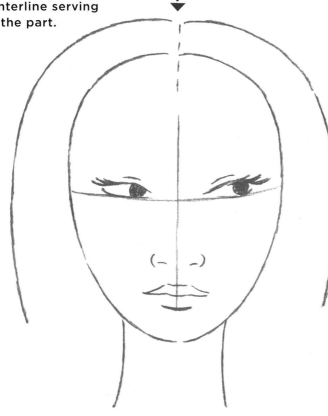

Make It Your Own

It's easier to create lips by drawing the contours in the first step. But if that proves difficult, just use a simple sketch line to get started. Try experimenting with different lip shapes and sizes.

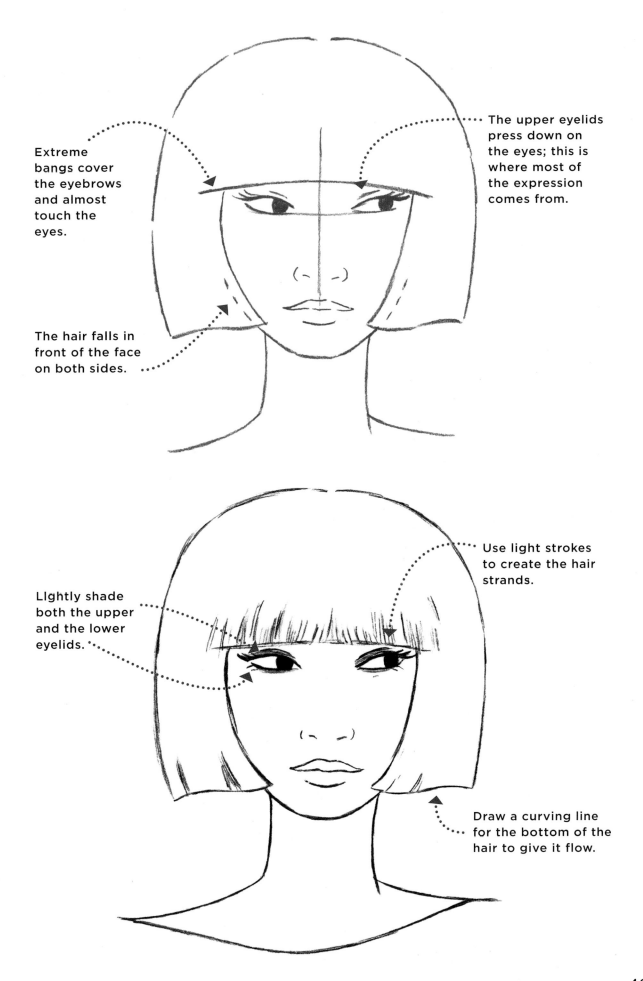

Extreme bangs cover the eyebrows and almost touch the eyes.

The upper eyelids press down on the eyes; this is where most of the expression comes from.

The hair falls in front of the face on both sides.

LIghtly shade both the upper and the lower eyelids.

Use light strokes to create the hair strands.

Draw a curving line for the bottom of the hair to give it flow.

CASUAL STYLE

At this angle, which is referred to by artists as a *¾ view,* we see only a small portion of the back of the head—but it's still important to show it.

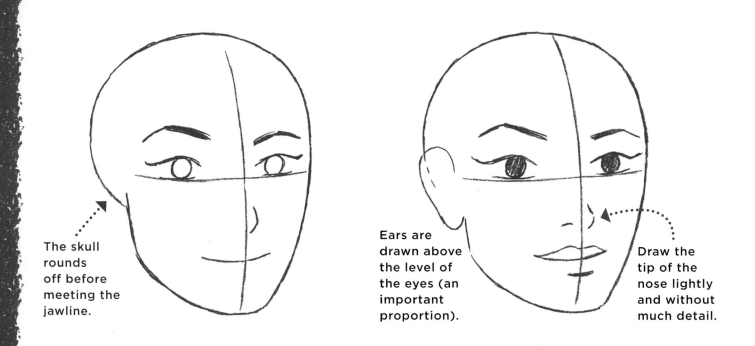

The skull rounds off before meeting the jawline.

Ears are drawn above the level of the eyes (an important proportion).

Draw the tip of the nose lightly and without much detail.

Let's do a check

☑ Are the eyebrows arching up?

☑ Are the eyelashes elongated and in place?

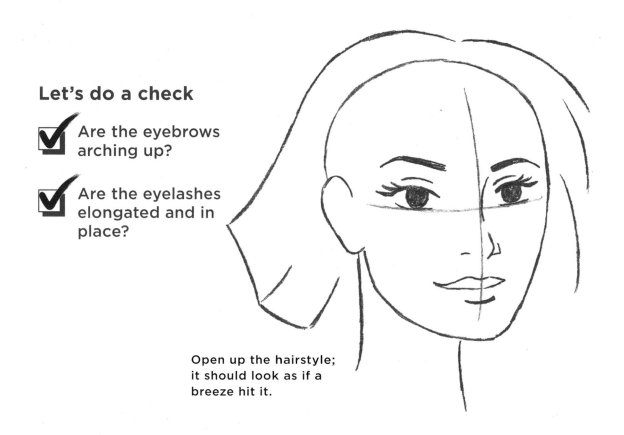

Open up the hairstyle; it should look as if a breeze hit it.

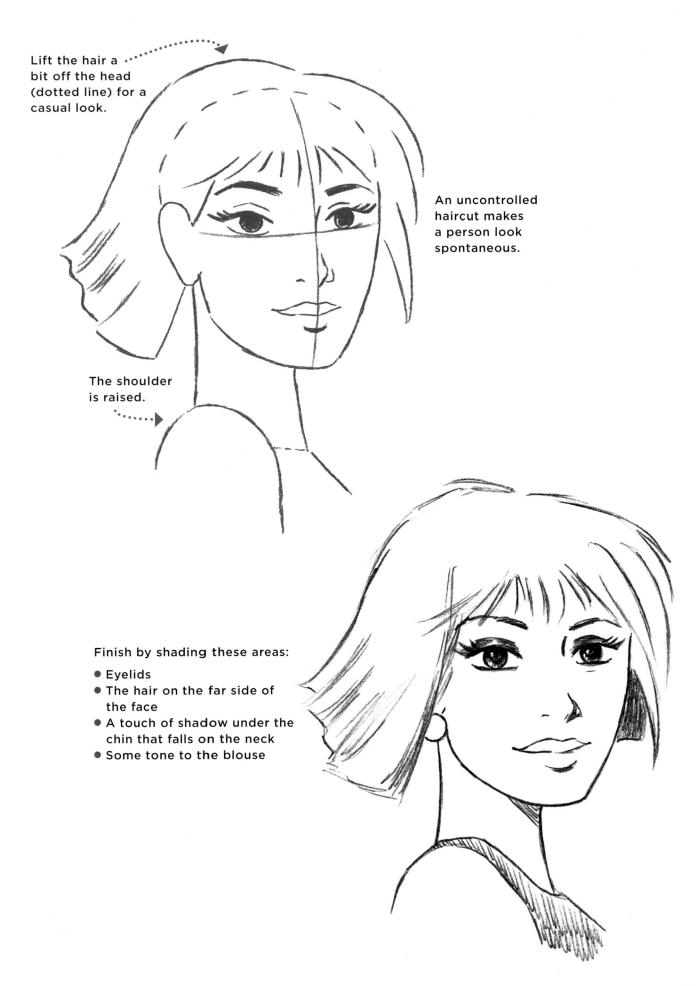

Lift the hair a bit off the head (dotted line) for a casual look.

An uncontrolled haircut makes a person look spontaneous.

The shoulder is raised.

Finish by shading these areas:
- Eyelids
- The hair on the far side of the face
- A touch of shadow under the chin that falls on the neck
- Some tone to the blouse

WOMAN IN SUNGLASSES

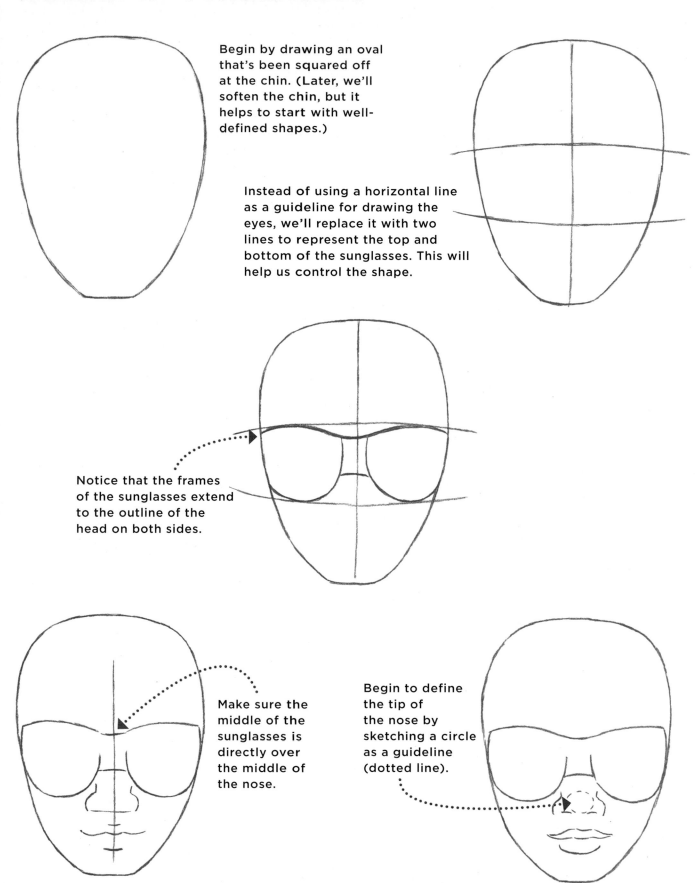

Begin by drawing an oval that's been squared off at the chin. (Later, we'll soften the chin, but it helps to start with well-defined shapes.)

Instead of using a horizontal line as a guideline for drawing the eyes, we'll replace it with two lines to represent the top and bottom of the sunglasses. This will help us control the shape.

Notice that the frames of the sunglasses extend to the outline of the head on both sides.

Make sure the middle of the sunglasses is directly over the middle of the nose.

Begin to define the tip of the nose by sketching a circle as a guideline (dotted line).

52

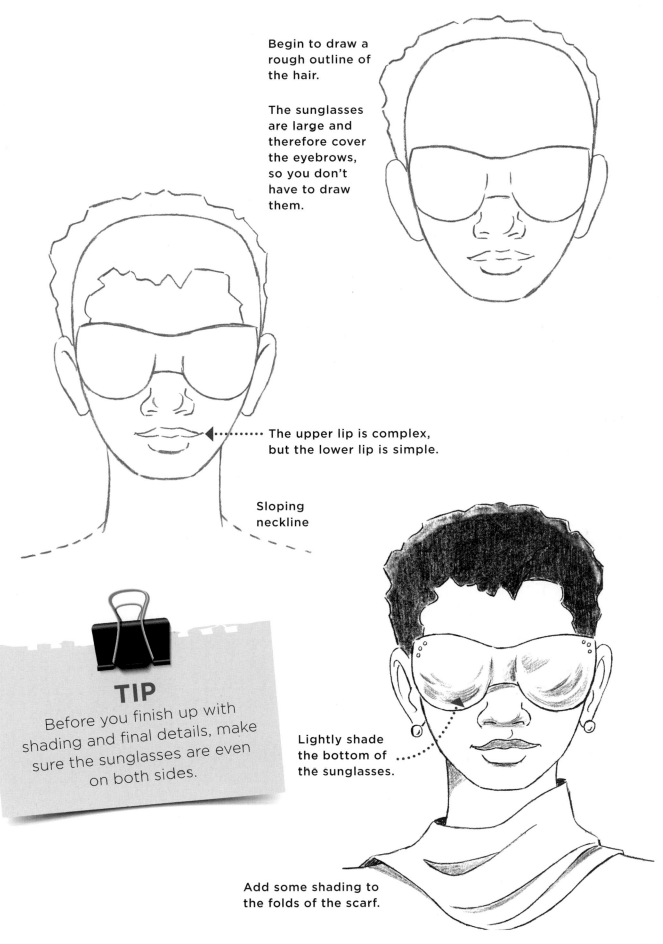

Begin to draw a rough outline of the hair.

The sunglasses are large and therefore cover the eyebrows, so you don't have to draw them.

The upper lip is complex, but the lower lip is simple.

Sloping neckline

TIP
Before you finish up with shading and final details, make sure the sunglasses are even on both sides.

Lightly shade the bottom of the sunglasses.

Add some shading to the folds of the scarf.

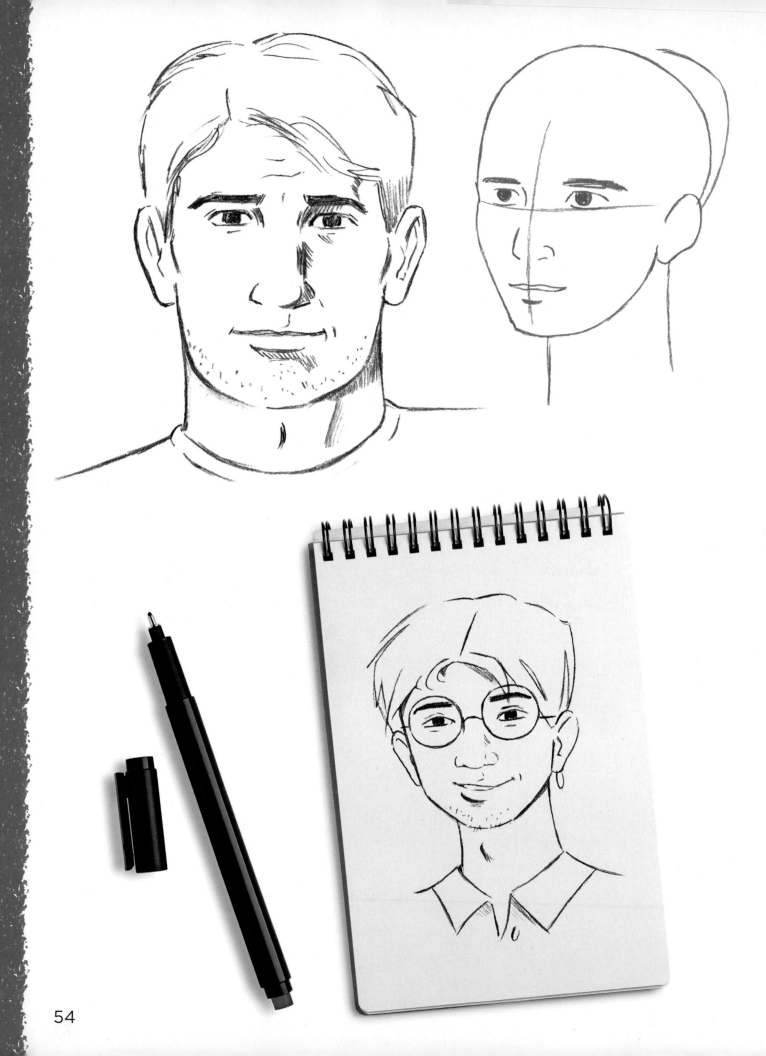

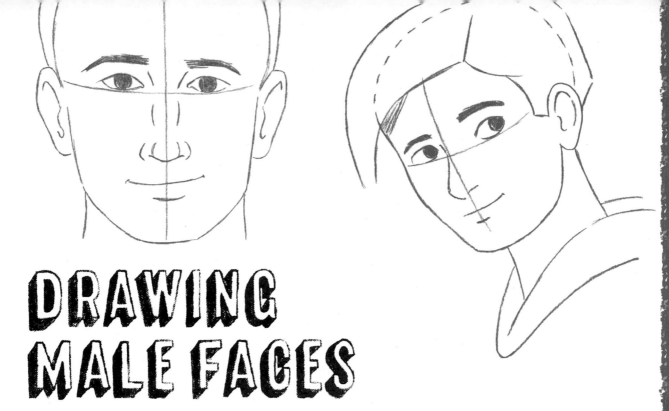

DRAWING MALE FACES

In this chapter, we'll cover a good assortment of male faces based on the same techniques we've previously discussed, with adjustments made for male characteristics. We'll vary the heads by angle (front, ¾, and profile) as well as expression, hairstyle, and features. Feel free to add your own touches along the way.

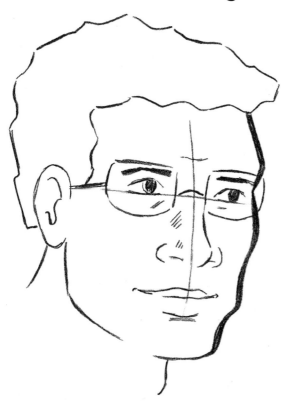

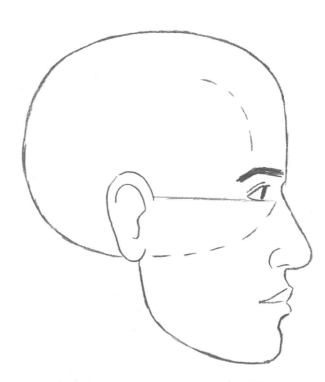

GUY IN GLASSES

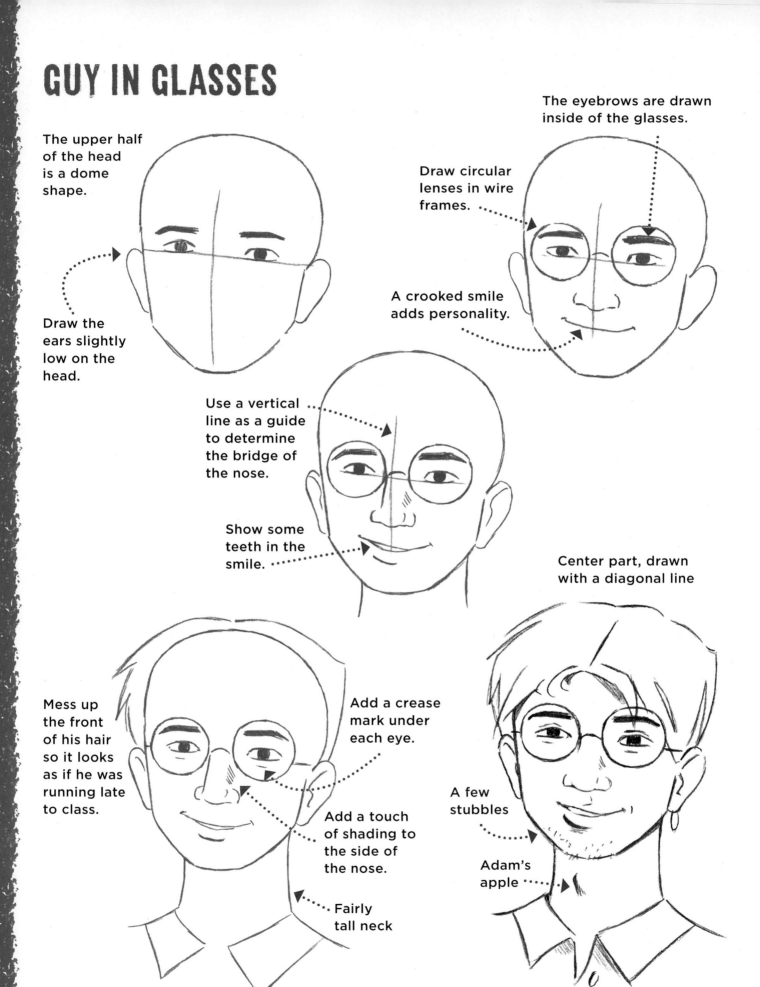

The upper half of the head is a dome shape.

Draw the ears slightly low on the head.

The eyebrows are drawn inside of the glasses.

Draw circular lenses in wire frames.

A crooked smile adds personality.

Use a vertical line as a guide to determine the bridge of the nose.

Show some teeth in the smile.

Center part, drawn with a diagonal line

Mess up the front of his hair so it looks as if he was running late to class.

Add a crease mark under each eye.

Add a touch of shading to the side of the nose.

Fairly tall neck

A few stubbles

Adam's apple

A GLANCE BACK

Draw the outline of the head so that it's tilted forward. Drawing a tilted centerline will help.

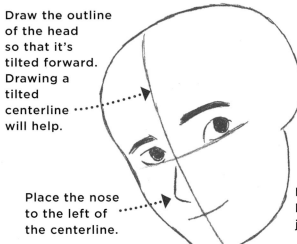

Place the nose to the left of the centerline.

Draw a soft-looking jawline.

Tuck the irises (colored part of the eyes) into the corners of the eyes, so that you show a lot of the whites of the eyes.

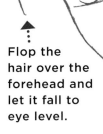

Flop the hair over the forehead and let it fall to eye level.

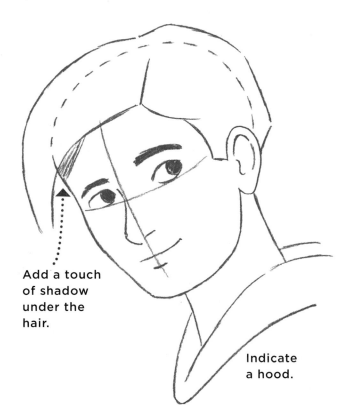

Add a touch of shadow under the hair.

Indicate a hood.

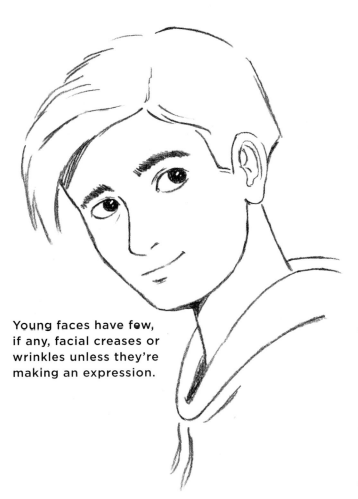

Young faces have few, if any, facial creases or wrinkles unless they're making an expression.

GUY IN HIS TWENTIES

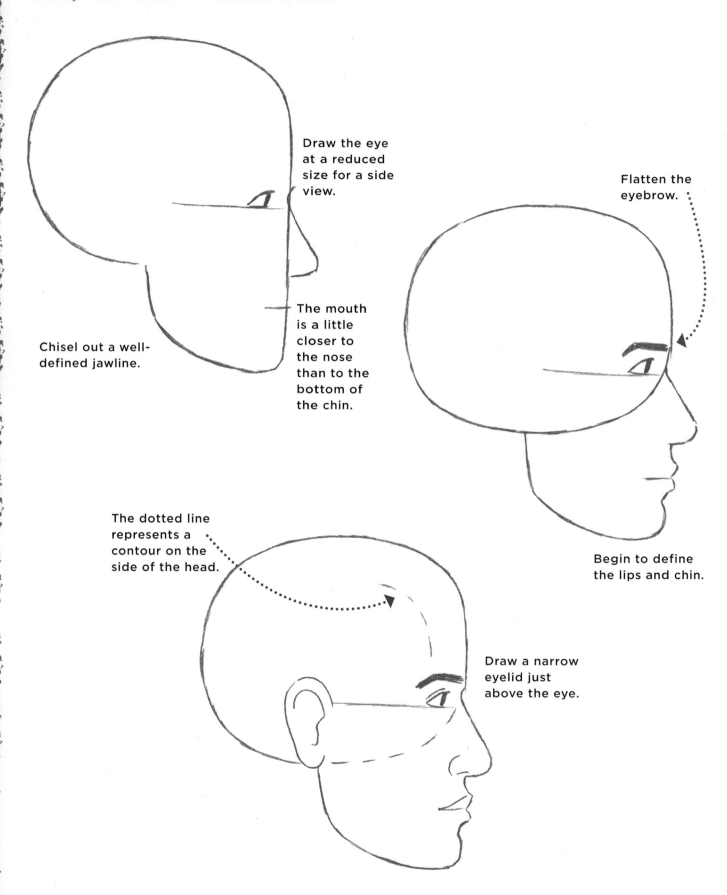

Draw the eye at a reduced size for a side view.

Chisel out a well-defined jawline.

The mouth is a little closer to the nose than to the bottom of the chin.

Flatten the eyebrow.

Begin to define the lips and chin.

The dotted line represents a contour on the side of the head.

Draw a narrow eyelid just above the eye.

58

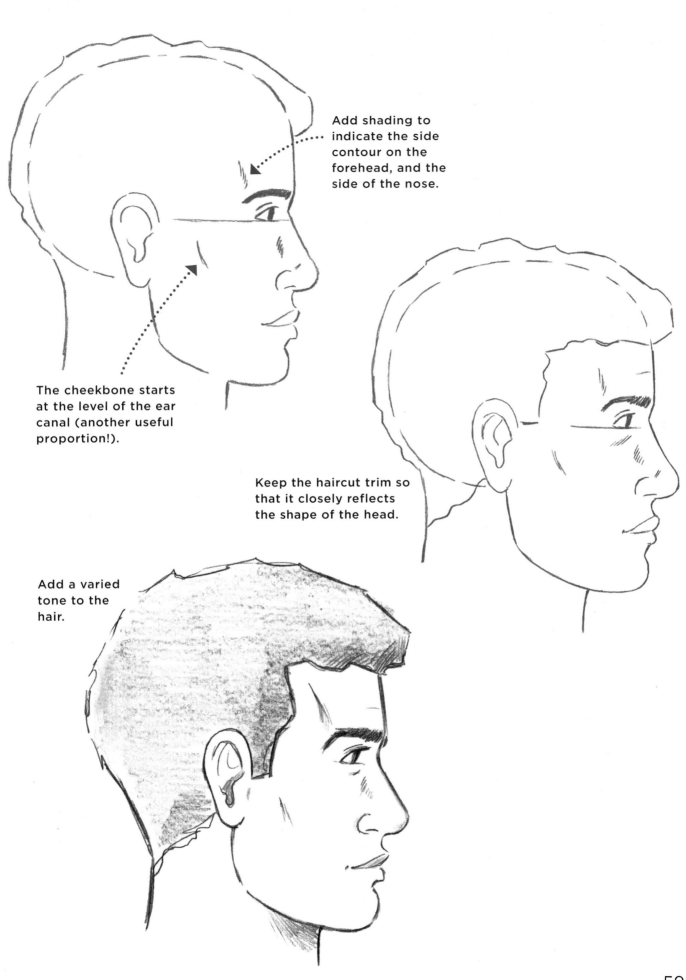

Add shading to indicate the side contour on the forehead, and the side of the nose.

The cheekbone starts at the level of the ear canal (another useful proportion!).

Keep the haircut trim so that it closely reflects the shape of the head.

Add a varied tone to the hair.

THOUGHTFUL TEEN

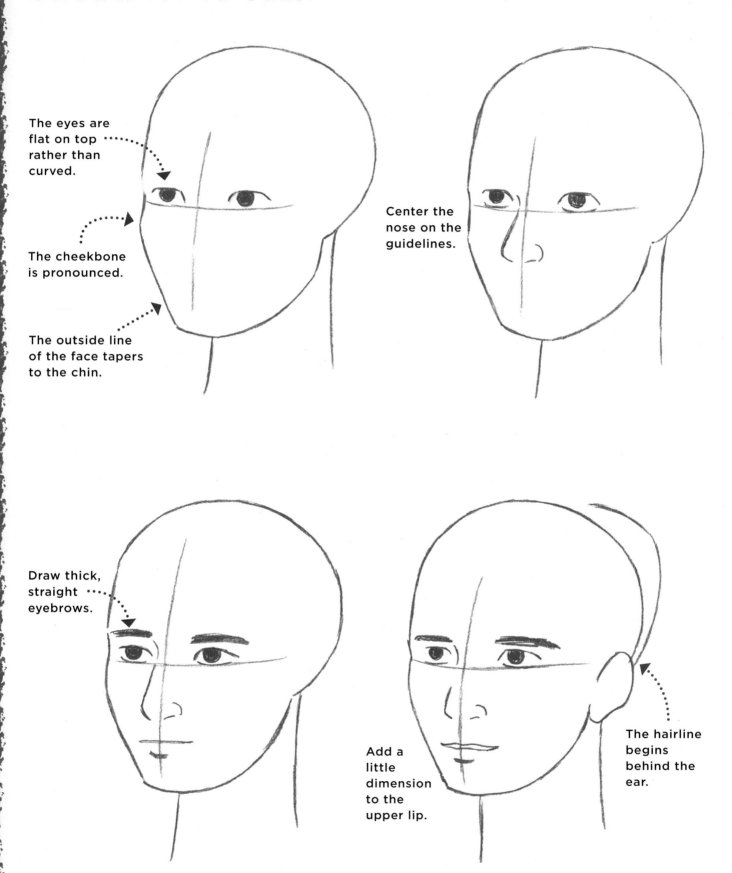

The eyes are flat on top rather than curved.

The cheekbone is pronounced.

The outside line of the face tapers to the chin.

Center the nose on the guidelines.

Draw thick, straight eyebrows.

Add a little dimension to the upper lip.

The hairline begins behind the ear.

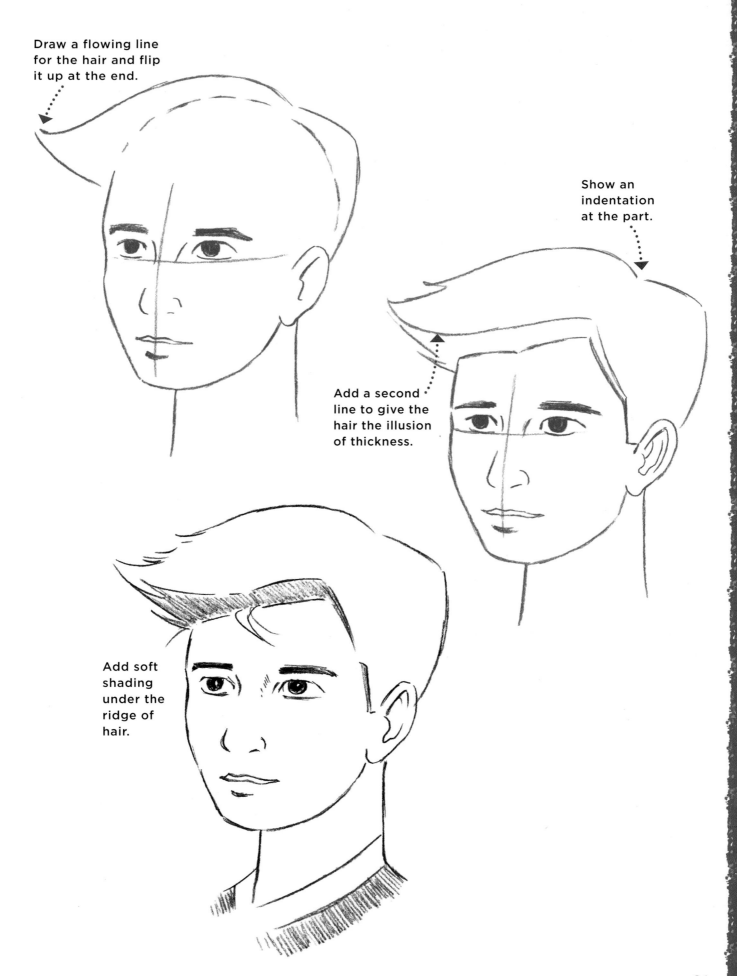

Draw a flowing line for the hair and flip it up at the end.

Show an indentation at the part.

Add a second line to give the hair the illusion of thickness.

Add soft shading under the ridge of hair.

SCRUFFY GUY

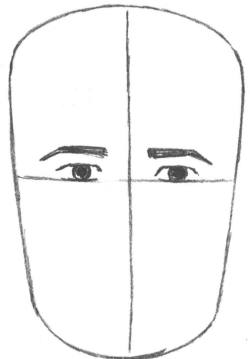

Draw a rectangular face.

Relatively small, rectangular eyes

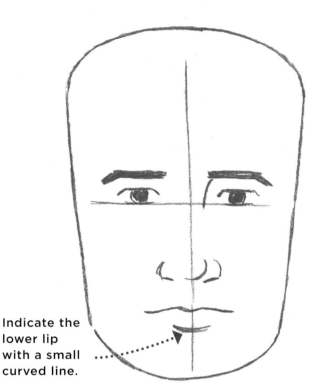

Indicate the lower lip with a small curved line.

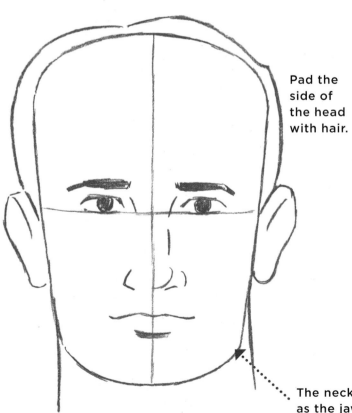

Pad the side of the head with hair.

The neck is as wide as the jawline, for a sturdy appearance.

Make It Your Own

You can create a variation on this drawing by rounding off the sides of the face to make it less square. This simple change is a good way to begin experimenting with the foundation shapes.

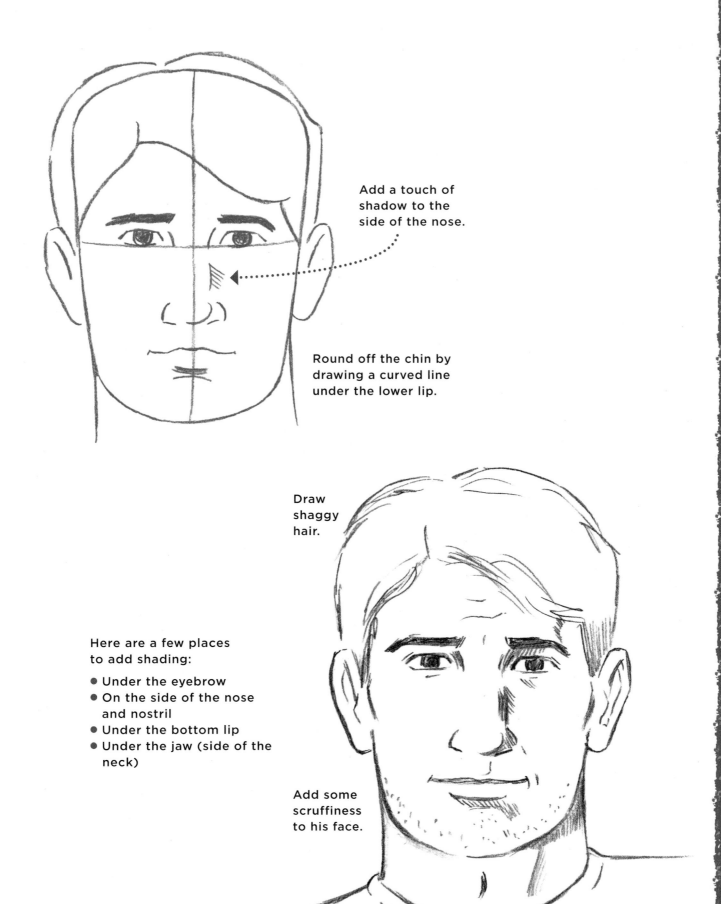

Add a touch of shadow to the side of the nose.

Round off the chin by drawing a curved line under the lower lip.

Draw shaggy hair.

Here are a few places to add shading:

- Under the eyebrow
- On the side of the nose and nostril
- Under the bottom lip
- Under the jaw (side of the neck)

Add some scruffiness to his face.

MIDDLE-AGED MAN

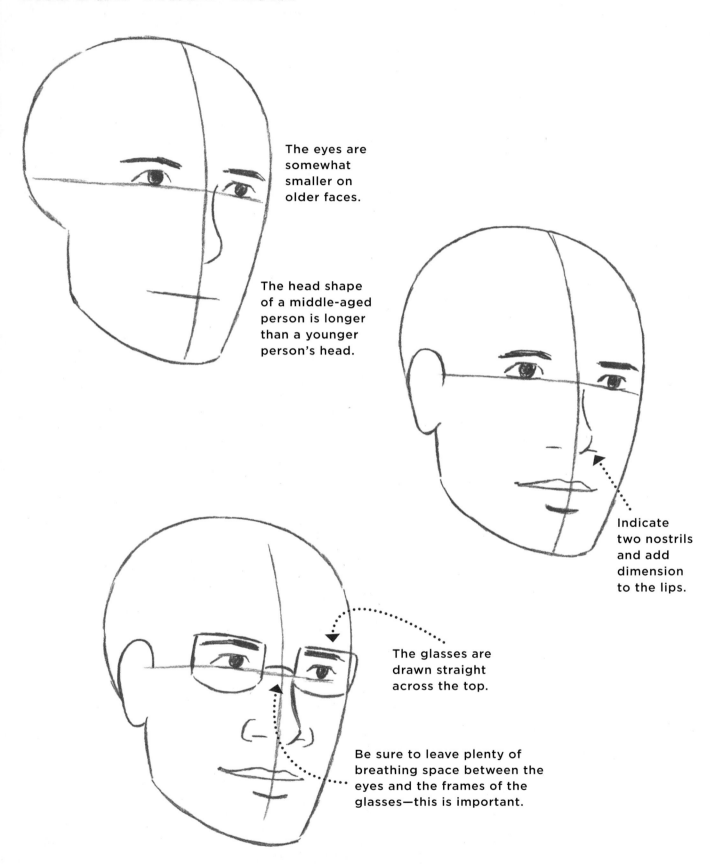

The eyes are somewhat smaller on older faces.

The head shape of a middle-aged person is longer than a younger person's head.

Indicate two nostrils and add dimension to the lips.

The glasses are drawn straight across the top.

Be sure to leave plenty of breathing space between the eyes and the frames of the glasses—this is important.

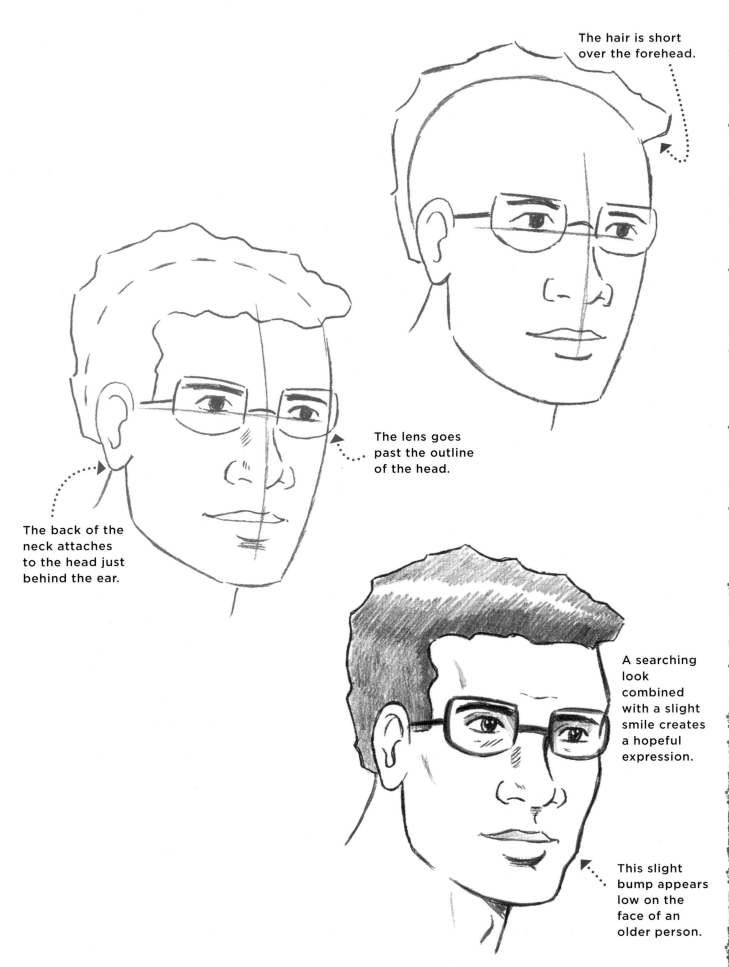

The hair is short over the forehead.

The lens goes past the outline of the head.

The back of the neck attaches to the head just behind the ear.

A searching look combined with a slight smile creates a hopeful expression.

This slight bump appears low on the face of an older person.

AFFABLE GUY

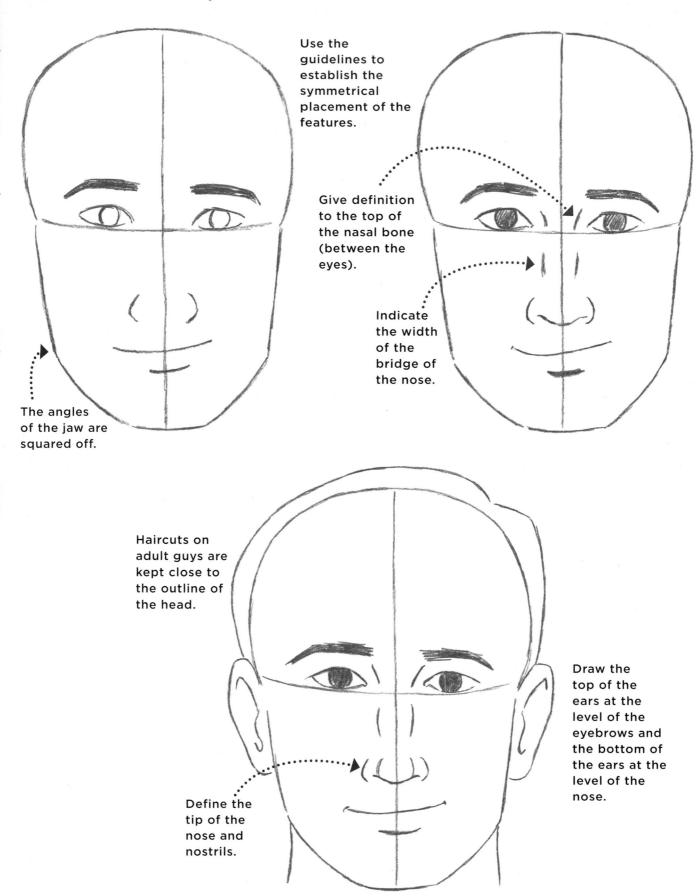

Use the guidelines to establish the symmetrical placement of the features.

Give definition to the top of the nasal bone (between the eyes).

Indicate the width of the bridge of the nose.

The angles of the jaw are squared off.

Haircuts on adult guys are kept close to the outline of the head.

Draw the top of the ears at the level of the eyebrows and the bottom of the ears at the level of the nose.

Define the tip of the nose and nostrils.

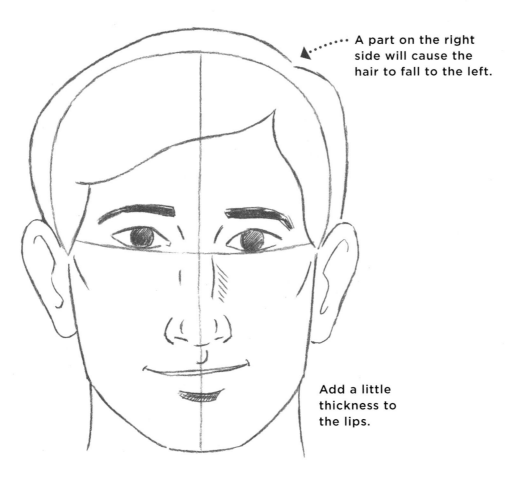

A part on the right side will cause the hair to fall to the left.

Add a little thickness to the lips.

Make It Your Own

The final drawing is created with varied tones of gray and black. The lightest tones are used for shading, while the darkest tones are used for the eyebrows and eyes to give them emphasis. You can adjust these tones if you like for different effects.

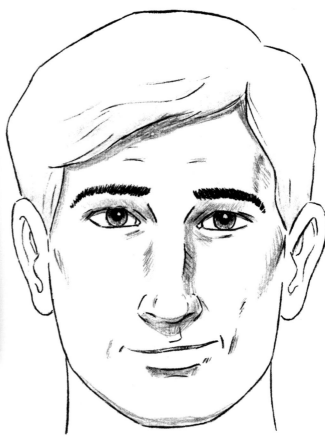

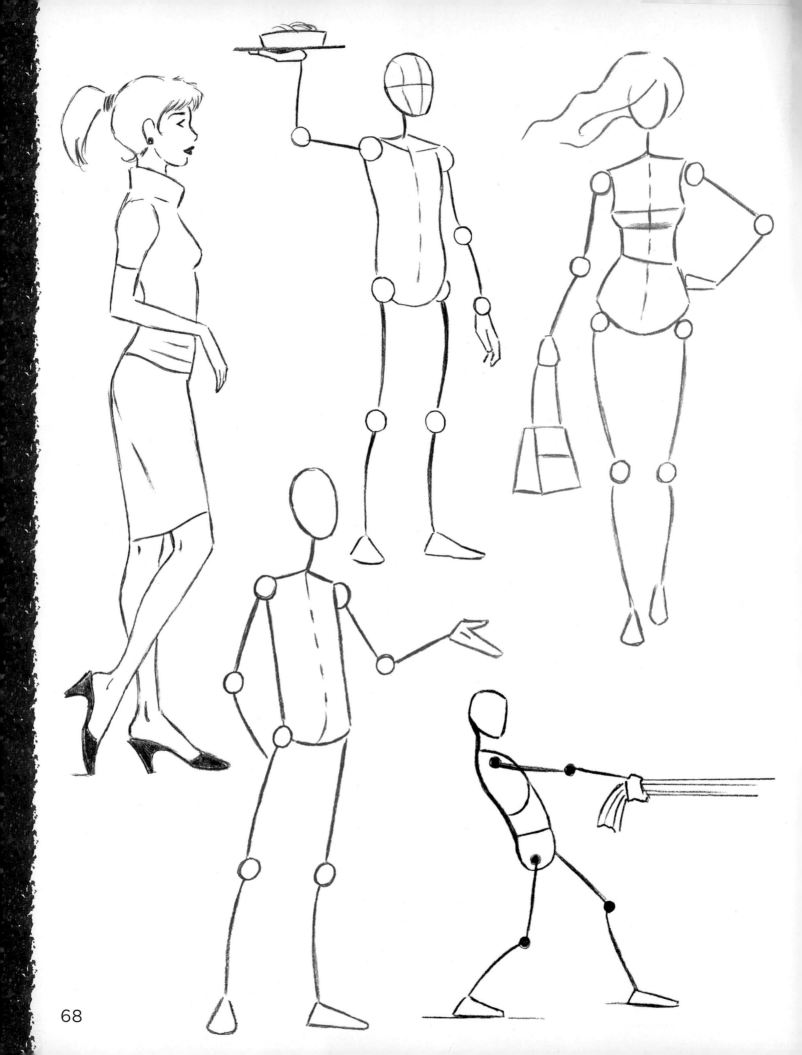

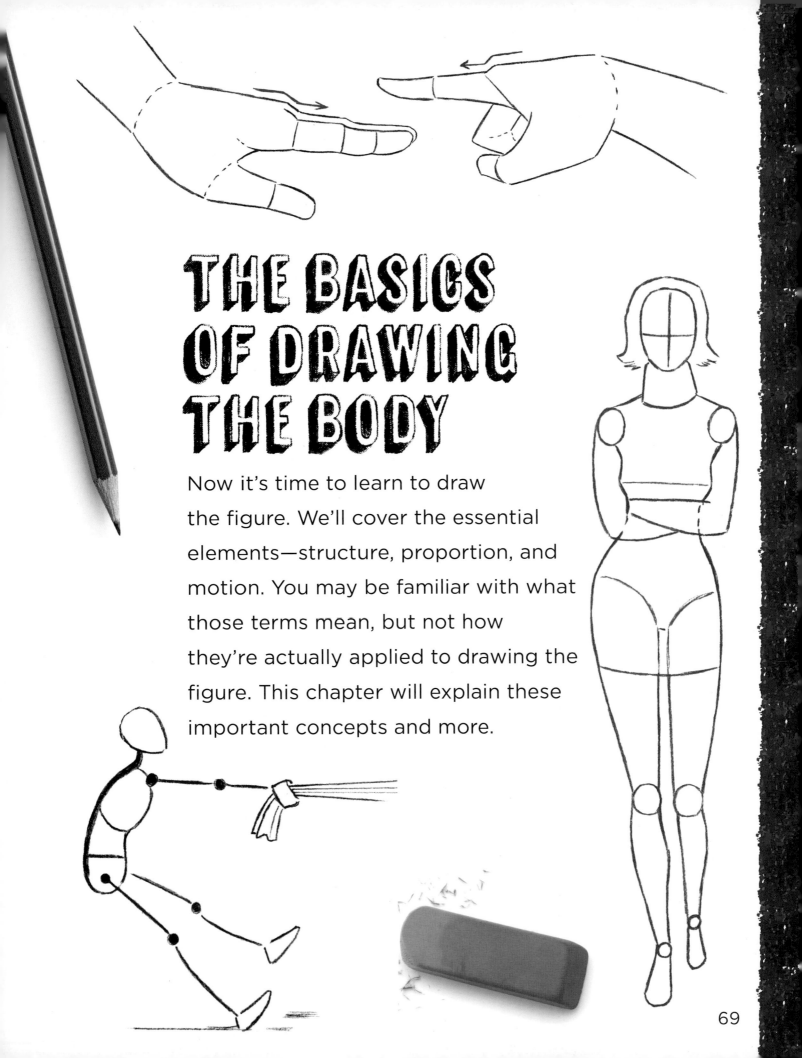

THE BASICS OF DRAWING THE BODY

Now it's time to learn to draw the figure. We'll cover the essential elements—structure, proportion, and motion. You may be familiar with what those terms mean, but not how they're actually applied to drawing the figure. This chapter will explain these important concepts and more.

BASIC CONCEPTS

The torso (shown with the dotted lines below) should form a simple shape. Using simple shapes for the foundation of the figure leads to finished drawings that appear uncomplicated and pleasing to the eye. When you draw a figure, you should be able to visualize the simple shape upon which it's based.

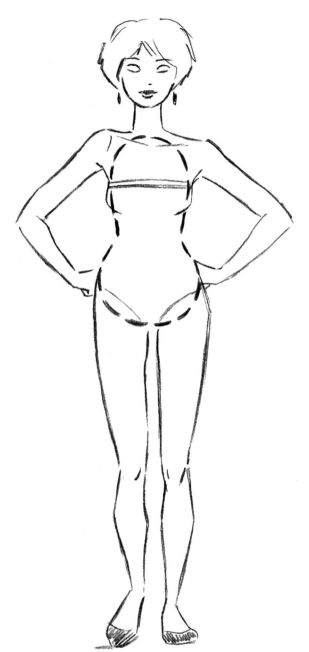

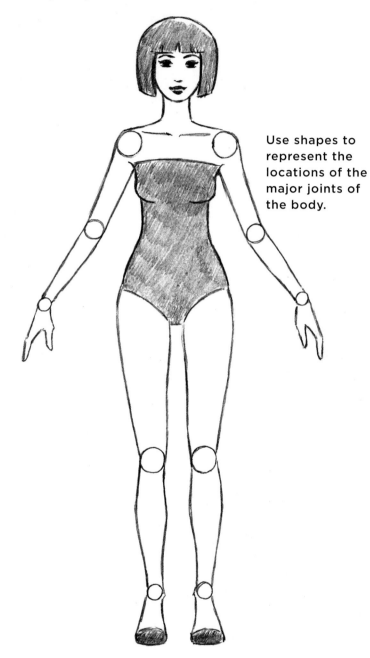

Use shapes to represent the locations of the major joints of the body.

Simple Torso Shape
The dotted lines show the simplified underlying shape hidden in the torso.

Keep It Consistent
Check to be sure that the limbs on both sides of the body are equal in length. You don't want one forearm to appear slightly shorter than the other. You don't have to get out a ruler. You can simply eyeball it and make any necessary adjustments.

More on Symmetry

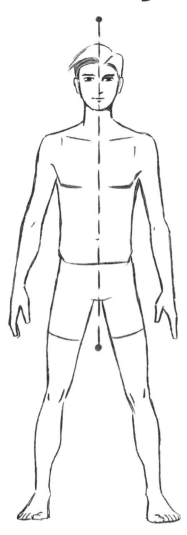

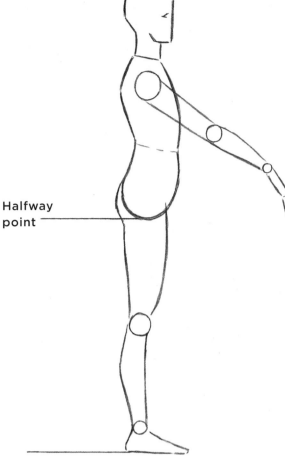

Halfway point

Vertical Guideline

Keeping your figures symmetrical is important. A good way to check this is to draw a vertical guideline straight down the middle of the figure. Overall, the left side should be equal in size to the right side.

Check Proportions

Occasionally checking the proportions is the easiest way to make the body appear correct. The most useful proportion is the halfway mark of the body, as measured up and down. Knowing this information can prevent the legs from appearing too long or too short.

Relaxed Posture

You often see stiff postures in how-to-draw books. But that's not how regular people stand. A relaxed posture is more interesting.

Bodies Are Based on Building Blocks

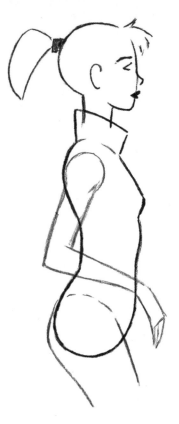

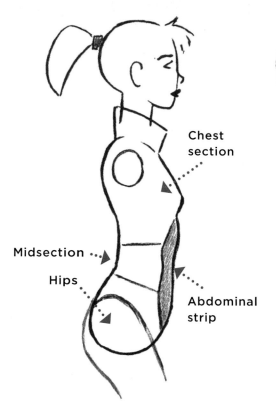

Chest
section

Midsection

Hips

Abdominal
strip

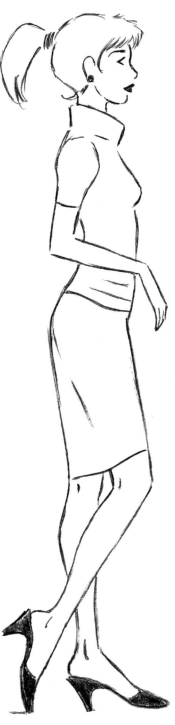

To the non-artist, the body appears to be a simple shape with a nice flow to it.

To the artist, the simple shape of the torso is created by seamlessly tying together various components.

When It Works, You Don't Even Notice It

As they say, it takes work to make something look simple. But the results are worth it. Even with the addition of clothes, the underlying dynamics of the pose are evident.

Movement Basics

Let's take a look at some of the principles of motion and their effects on the body. This will come in handy when we get to the section on drawing athletes.

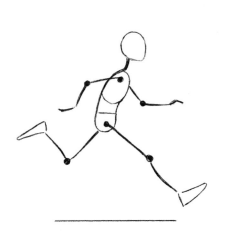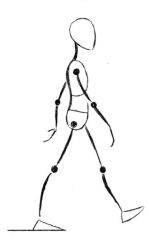

Walking Versus Running

You've no doubt observed that people extend their legs more when they run than when they walk. Similarly, they swing their arms more, too. In addition, the spine curves more in a run, but maintains good standing posture in a walk.

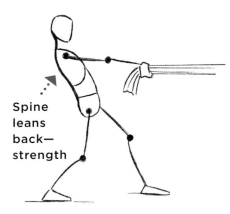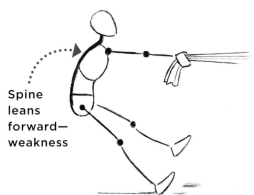

Spine leans back—strength

Spine leans forward—weakness

Stress and Posture

The direction the spine leans toward when pulling indicates weakness or strength.

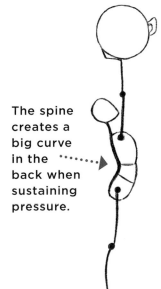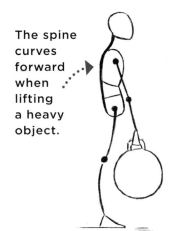

The spine creates a big curve in the back when sustaining pressure.

The spine curves forward when lifting a heavy object.

Lifting Heavy Objects

The spine is not a straight line. It flexes inward and outward.

DRAWING HANDS

Let's take a moment to practice drawing hands. We'll use some of the same tools, like the centerline and the combination of basic shapes, to create the logical constructions on which we'll base our drawings. Feel free to make changes—if you have an idea for a different finger or thumb position, try it!

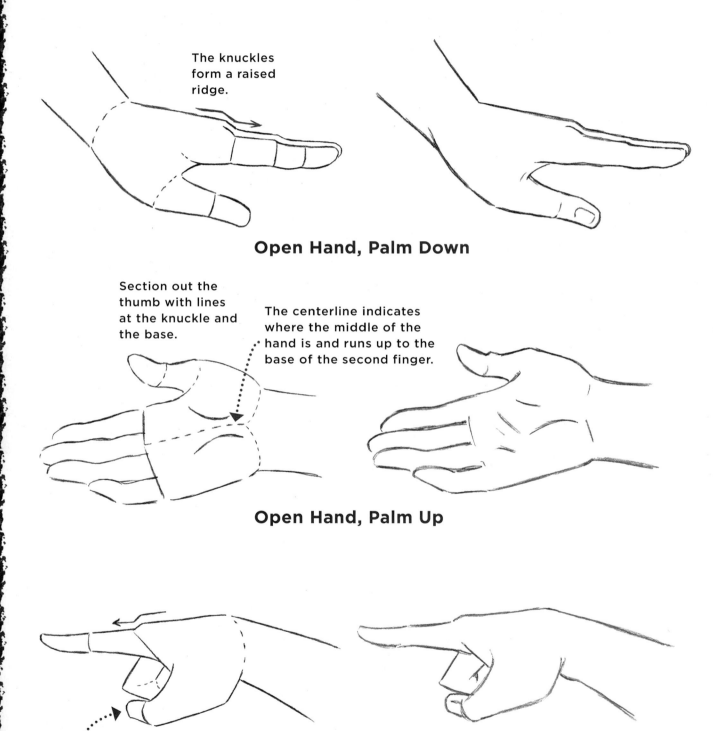

The knuckles form a raised ridge.

Open Hand, Palm Down

Section out the thumb with lines at the knuckle and the base.

The centerline indicates where the middle of the hand is and runs up to the base of the second finger.

Open Hand, Palm Up

Like a latch, the thumb holds the fingers in place.

Finger Point with Thumb Wrapped Around

Extend the thumb and forefinger and curl the rest of the fingers underneath.

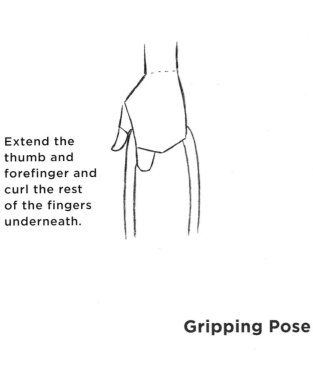

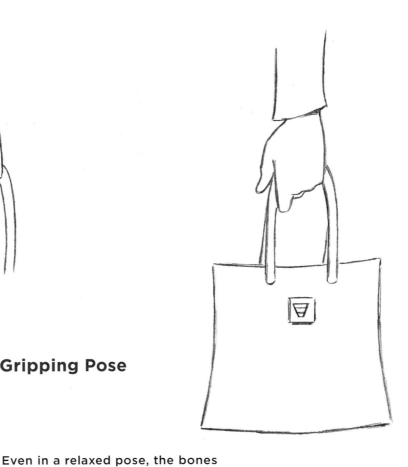

Gripping Pose

Even in a relaxed pose, the bones of the hand retain their shape, as seen in the ridge of the knuckles.

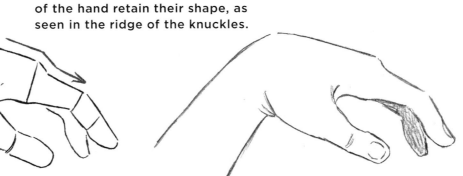

Relaxed Pose

Group the fingers together so that they overlap each other, with the nearest one (the pinky) appearing to be the widest.

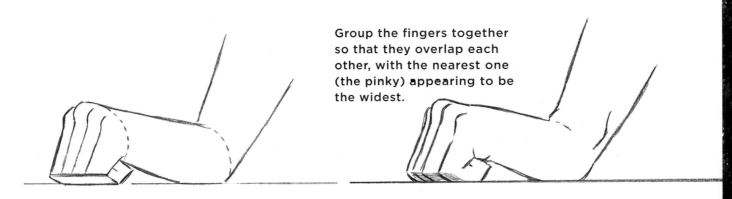

Knuckles Resting on Tabletop

WARM-UPS

Now I'll introduce you to special types of stick figures: ones that have shapes for the torso. They're more accurate than one-dimensional stick drawings while remaining basic. This stick-figure construction is useful for demonstrating a few concepts about poses.

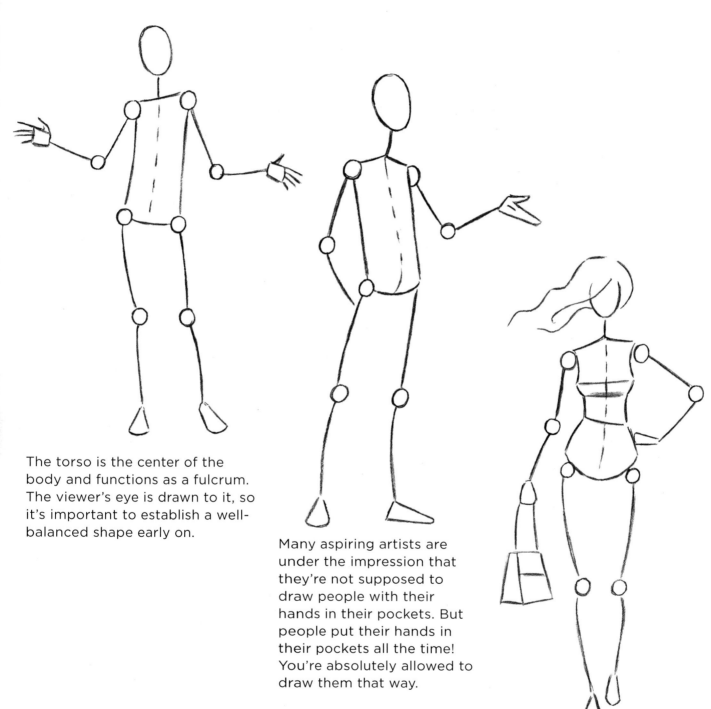

The torso is the center of the body and functions as a fulcrum. The viewer's eye is drawn to it, so it's important to establish a well-balanced shape early on.

Many aspiring artists are under the impression that they're not supposed to draw people with their hands in their pockets. But people put their hands in their pockets all the time! You're absolutely allowed to draw them that way.

The hips are wider on the female body, and the legs converge at the bottom.

More Tips

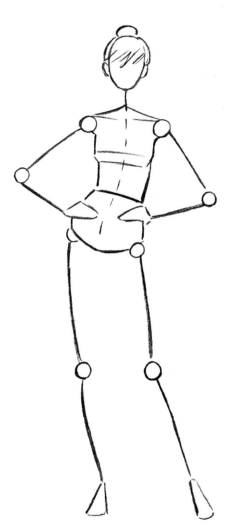

You don't need to get fancy. You can create an interesting pose with something as simple as a shift of the hips.

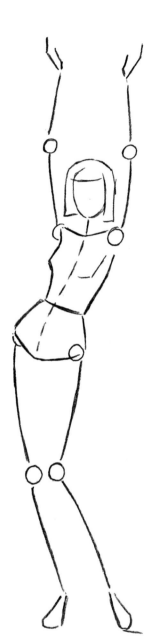

An inward bending knee adds attitude. The raised arms may get attention, but the bent knee shows us she's having fun.

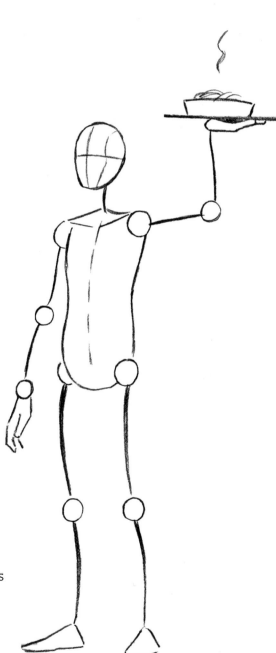

When the shoulders are level, the hips are generally level as well. (Good thing for his customers!)

FILLED-OUT CONSTRUCTIONS

Stick figures are a good place to start, but it's a pretty big jump to go from a stick figure to a finished drawing. Fortunately for us, there's a middle step: filled-in constructions. These figures are more realistic, but not quite in their final form yet. They make it easier to draw a finished head and body.

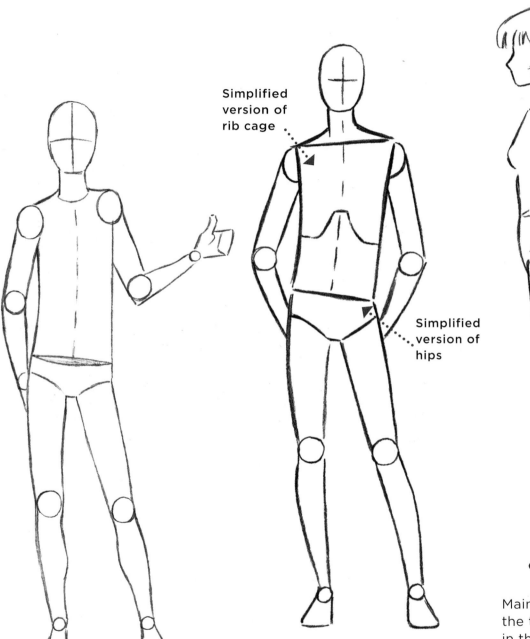

Simplified version of rib cage

Simplified version of hips

Maintain a round look to the torso, hips, and joints in the side view. Don't allow it to flatten out.

Posing Tip
An easy way to create variations of a pose is to change the position of the arms or legs.

When you fill in the construction, everything looks solid. It's still simple, like the stick figure, but conveys the idea of a body with volume and dimension.

78

Basic Construction for Advanced Poses

You can practice drawing the basic constructions below as a warm-up for drawing fully finished figures in more advanced poses.

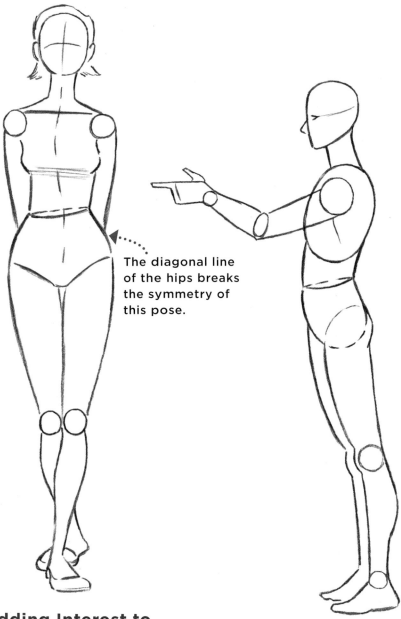

The diagonal line of the hips breaks the symmetry of this pose.

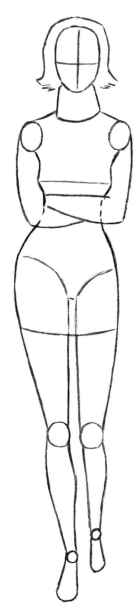

Adding Interest to a Standing Pose

Another way to add interest to a standing pose is by crossing the legs. They can be crossed at the knees, mid-calf, or ankles. This picture shows the legs crossed at mid-calf.

Using Gestures

By drawing the body in profile and extending the arm in a gesture, you immediately make a basic standing pose more interesting.

Draw the Construction First

In the next chapter, we'll see how clothes look more natural on the figure when the construction step is drawn first.

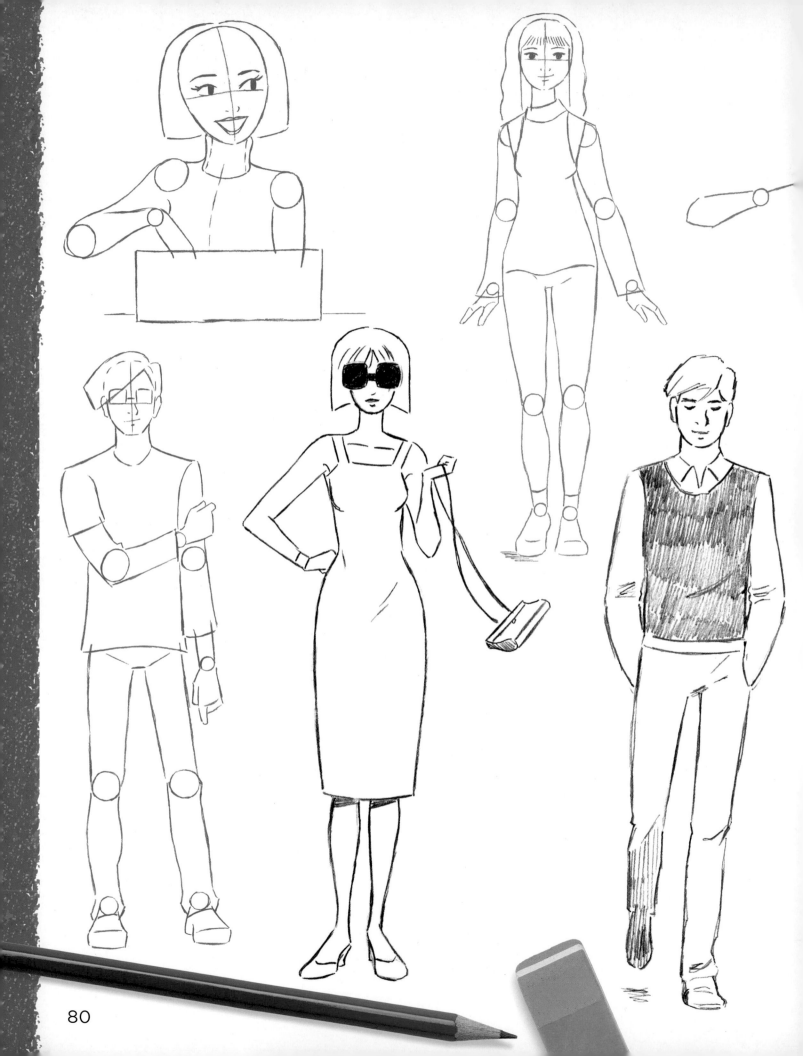

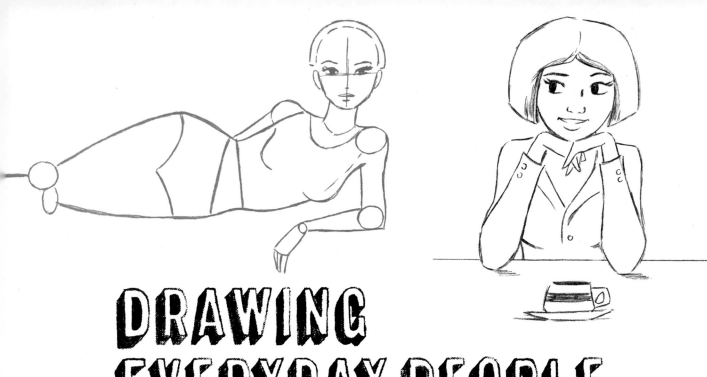

DRAWING EVERYDAY PEOPLE

Let's take the concepts we've just covered and apply them, step by step, to a variety of everyday people. Don't put too much pressure on yourself to get it right on the first try. Professional artists go through a number of drafts before they finalize a drawing. As I often say, if you're not making mistakes, you're not trying new things.

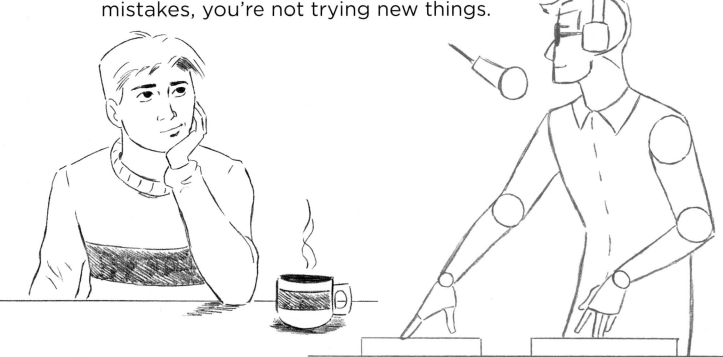

WHERE DO YOU WANT THIS PLANT TO GO?

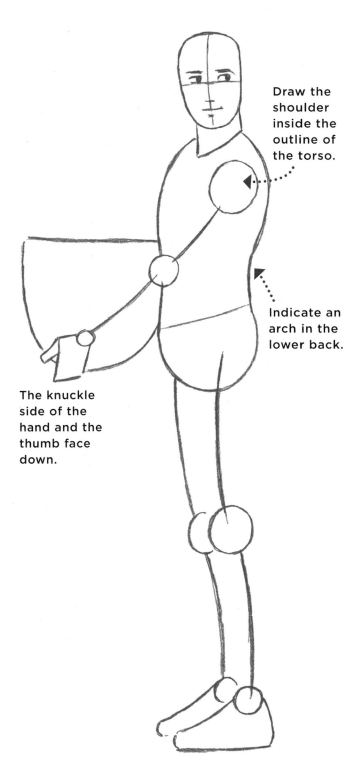

Draw the shoulder inside the outline of the torso.

Indicate an arch in the lower back.

The knuckle side of the hand and the thumb face down.

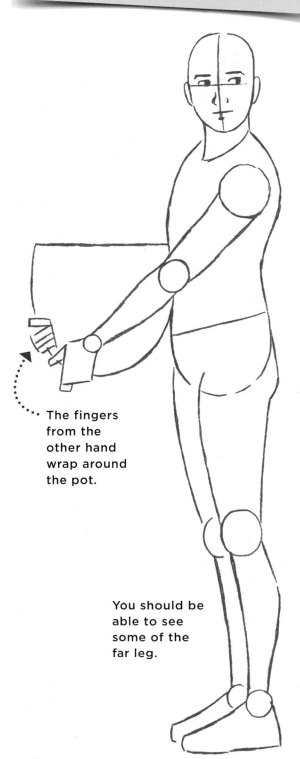

The fingers from the other hand wrap around the pot.

You should be able to see some of the far leg.

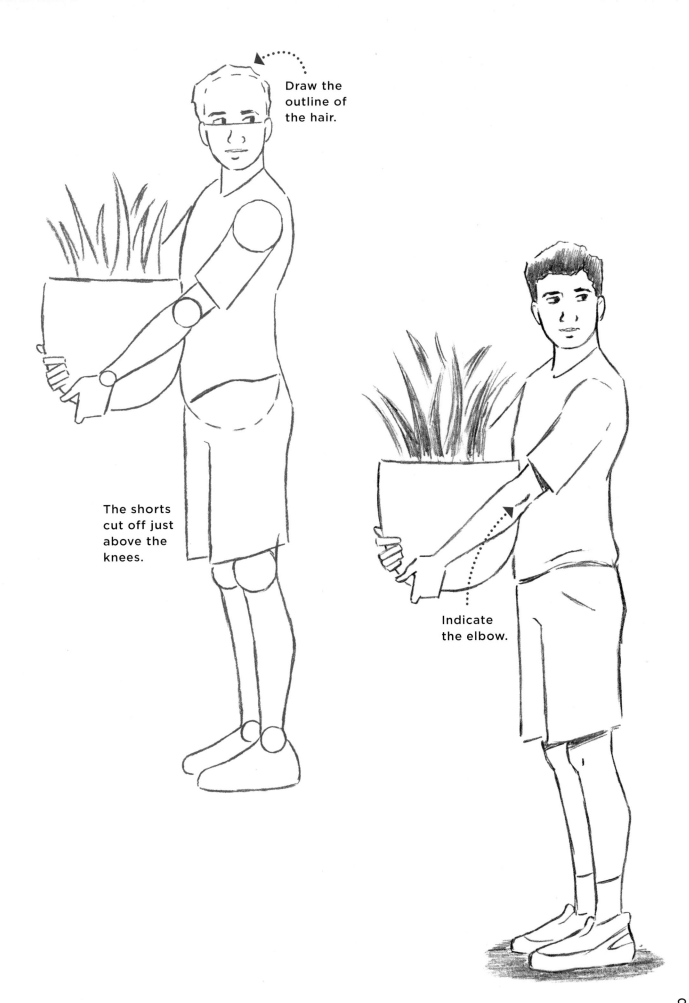

Draw the outline of the hair.

The shorts cut off just above the knees.

Indicate the elbow.

STYLISH WALKING POSE

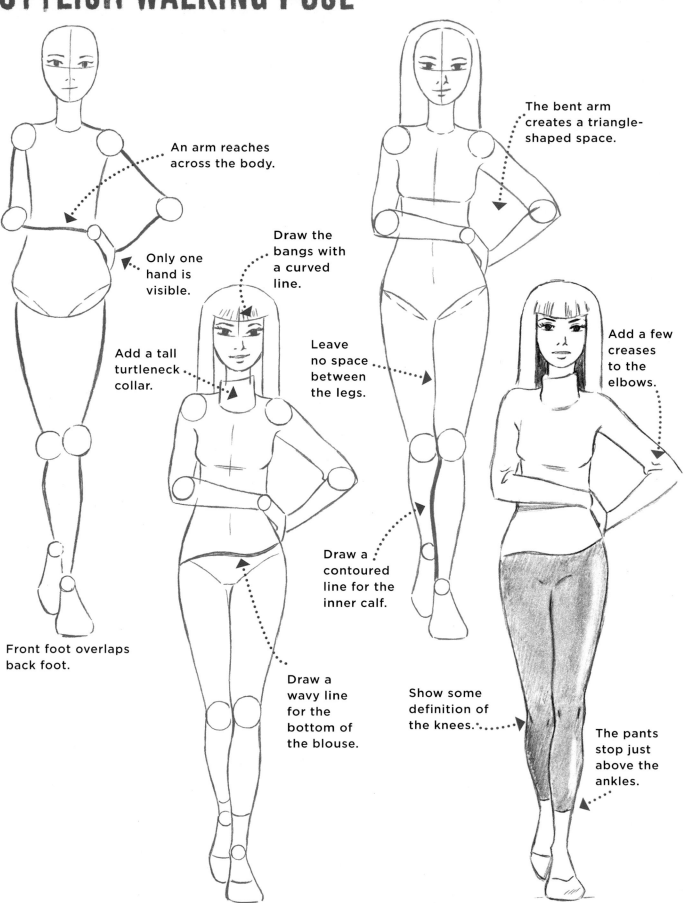

An arm reaches across the body.

The bent arm creates a triangle-shaped space.

Only one hand is visible.

Draw the bangs with a curved line.

Add a few creases to the elbows.

Add a tall turtleneck collar.

Leave no space between the legs.

Draw a contoured line for the inner calf.

Front foot overlaps back foot.

Draw a wavy line for the bottom of the blouse.

Show some definition of the knees.

The pants stop just above the ankles.

TAKING IT EASY

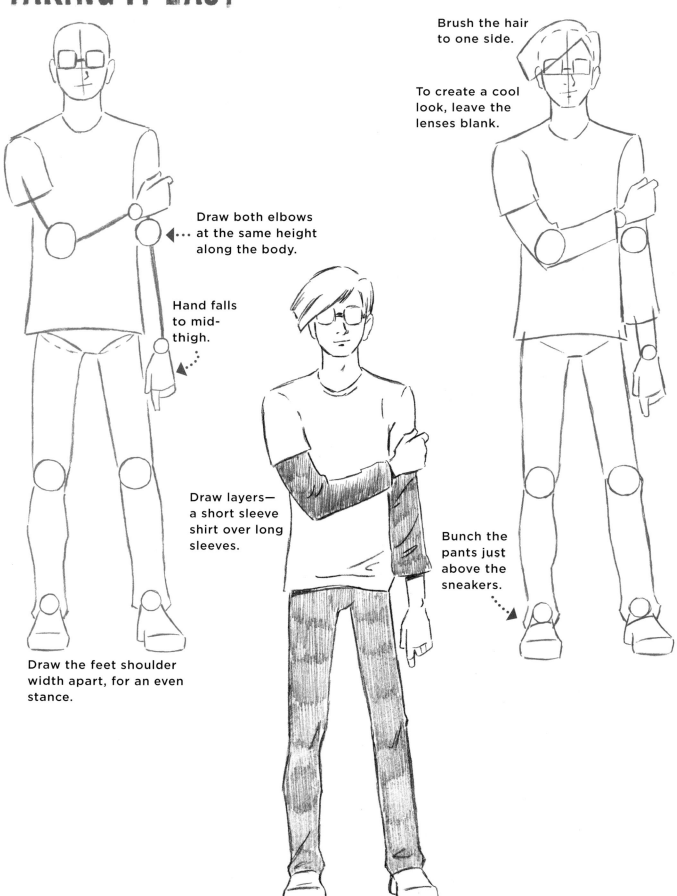

Brush the hair to one side.

To create a cool look, leave the lenses blank.

Draw both elbows at the same height along the body.

Hand falls to mid-thigh.

Draw layers— a short sleeve shirt over long sleeves.

Bunch the pants just above the sneakers.

Draw the feet shoulder width apart, for an even stance.

STUDENT WITH GYM BAG

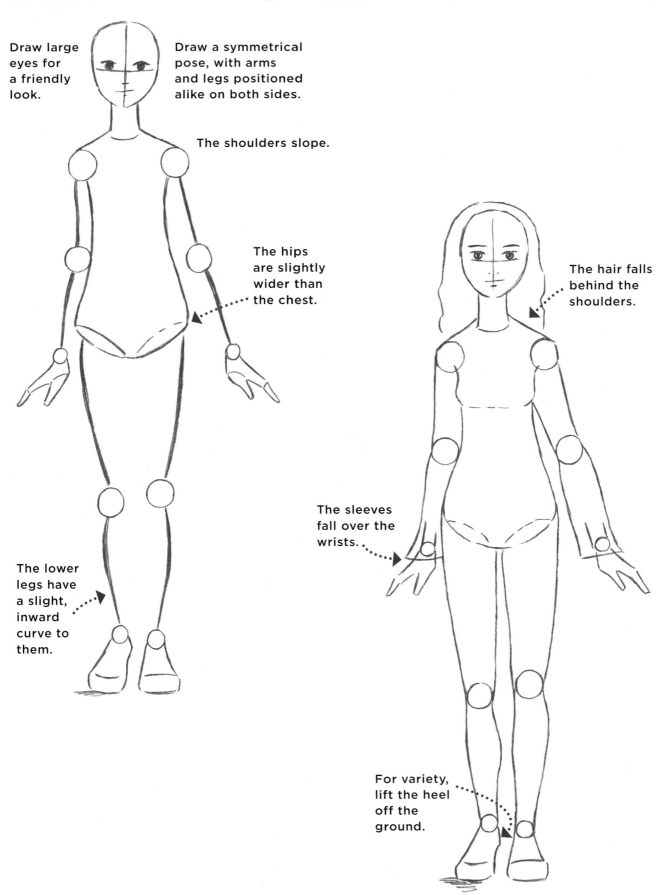

Draw large eyes for a friendly look.

Draw a symmetrical pose, with arms and legs positioned alike on both sides.

The shoulders slope.

The hips are slightly wider than the chest.

The lower legs have a slight, inward curve to them.

The hair falls behind the shoulders.

The sleeves fall over the wrists.

For variety, lift the heel off the ground.

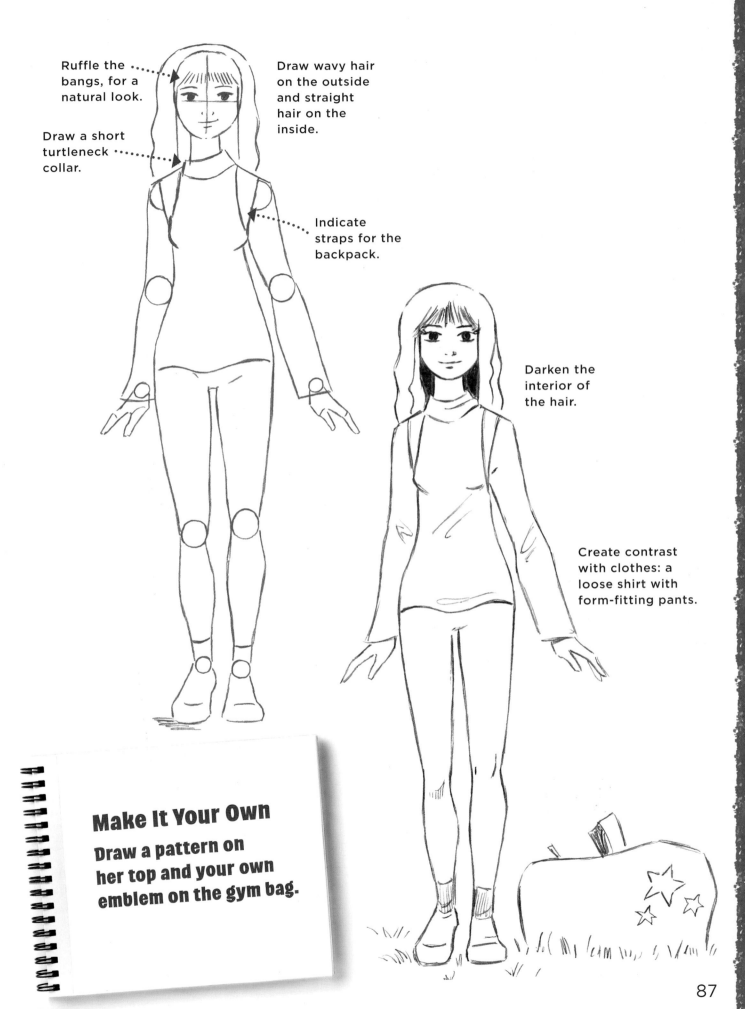

Ruffle the bangs, for a natural look.

Draw wavy hair on the outside and straight hair on the inside.

Draw a short turtleneck collar.

Indicate straps for the backpack.

Darken the interior of the hair.

Create contrast with clothes: a loose shirt with form-fitting pants.

Make It Your Own

Draw a pattern on her top and your own emblem on the gym bag.

MAN WALKING, FRONT ANGLE

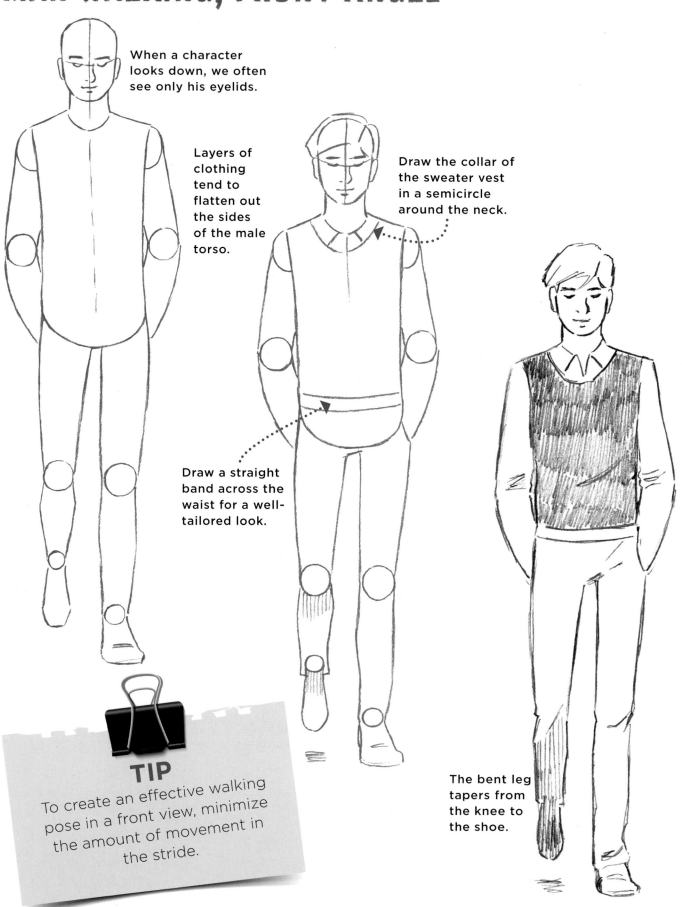

When a character looks down, we often see only his eyelids.

Layers of clothing tend to flatten out the sides of the male torso.

Draw the collar of the sweater vest in a semicircle around the neck.

Draw a straight band across the waist for a well-tailored look.

TIP
To create an effective walking pose in a front view, minimize the amount of movement in the stride.

The bent leg tapers from the knee to the shoe.

FASHIONABLE FIGURE

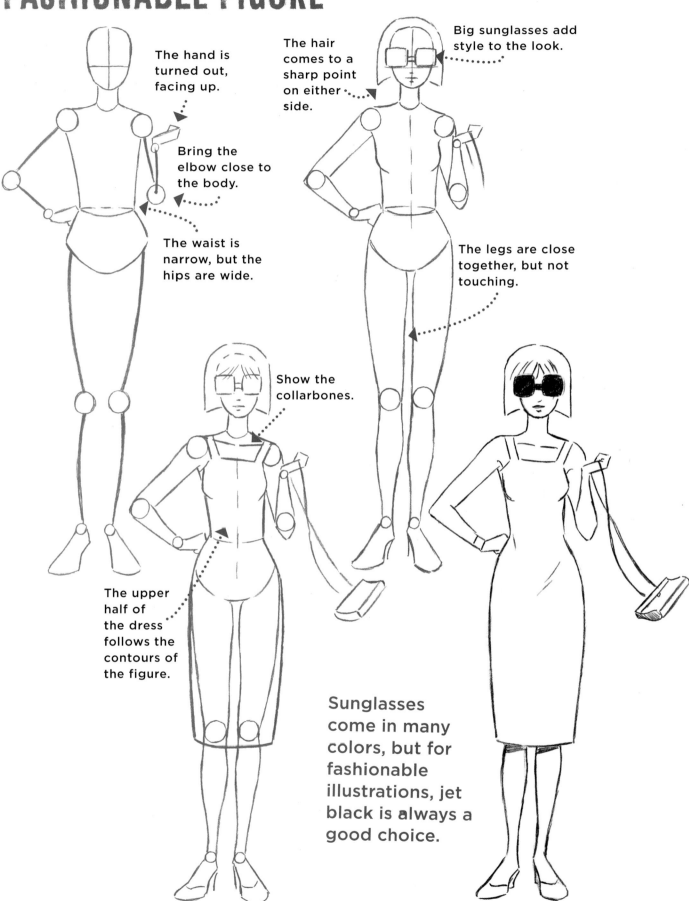

The hand is turned out, facing up.

Bring the elbow close to the body.

The waist is narrow, but the hips are wide.

The hair comes to a sharp point on either side.

Big sunglasses add style to the look.

The legs are close together, but not touching.

Show the collarbones.

The upper half of the dress follows the contours of the figure.

Sunglasses come in many colors, but for fashionable illustrations, jet black is always a good choice.

DAYDREAMER

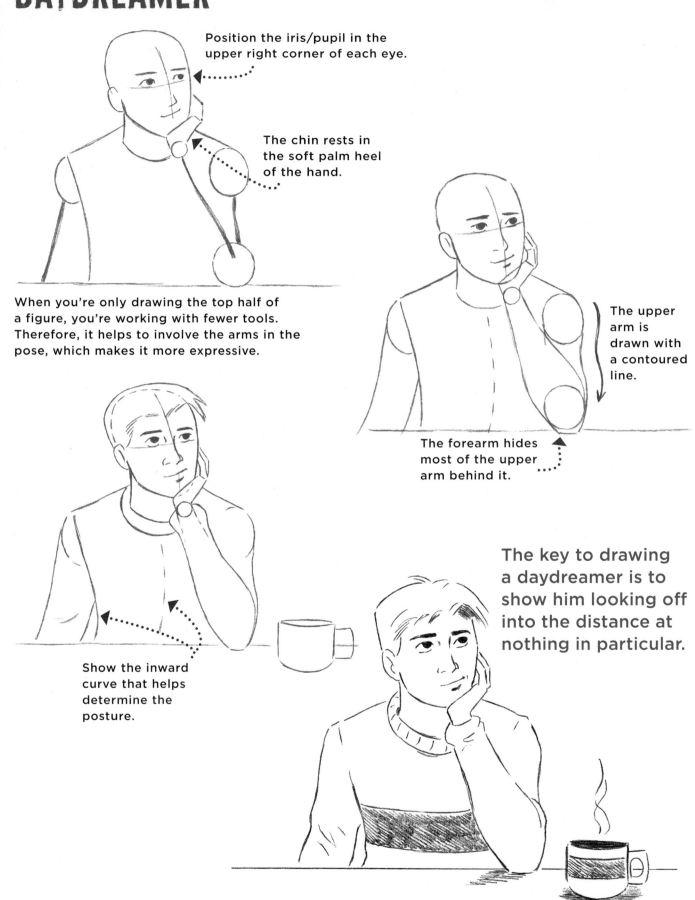

Position the iris/pupil in the upper right corner of each eye.

The chin rests in the soft palm heel of the hand.

When you're only drawing the top half of a figure, you're working with fewer tools. Therefore, it helps to involve the arms in the pose, which makes it more expressive.

The upper arm is drawn with a contoured line.

The forearm hides most of the upper arm behind it.

Show the inward curve that helps determine the posture.

The key to drawing a daydreamer is to show him looking off into the distance at nothing in particular.

A CUTE LOOK

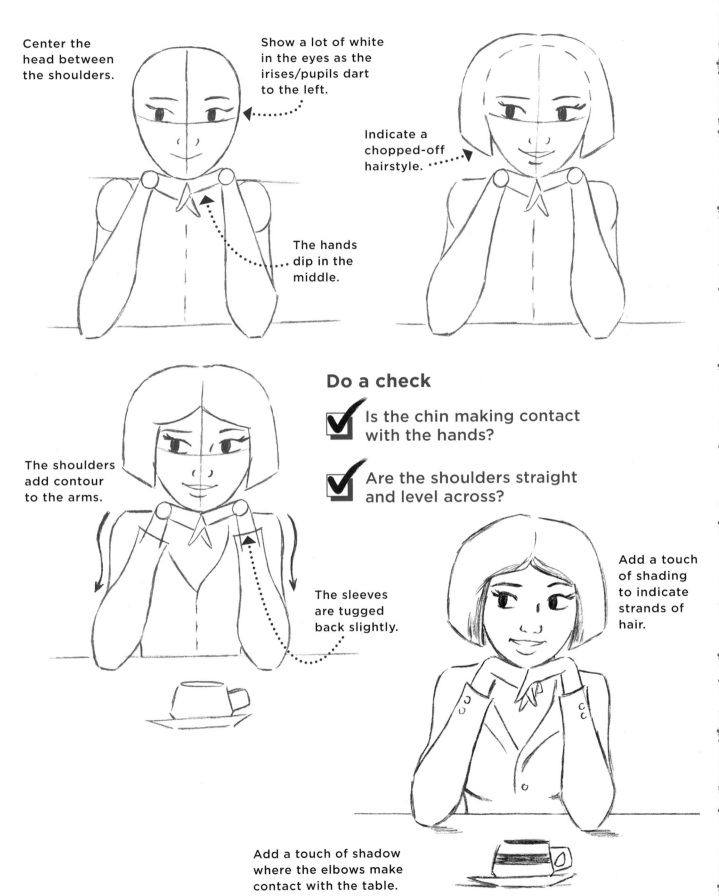

Center the head between the shoulders.

Show a lot of white in the eyes as the irises/pupils dart to the left.

Indicate a chopped-off hairstyle.

The hands dip in the middle.

The shoulders add contour to the arms.

The sleeves are tugged back slightly.

Do a check

☑ Is the chin making contact with the hands?

☑ Are the shoulders straight and level across?

Add a touch of shading to indicate strands of hair.

Add a touch of shadow where the elbows make contact with the table.

FOR ME?

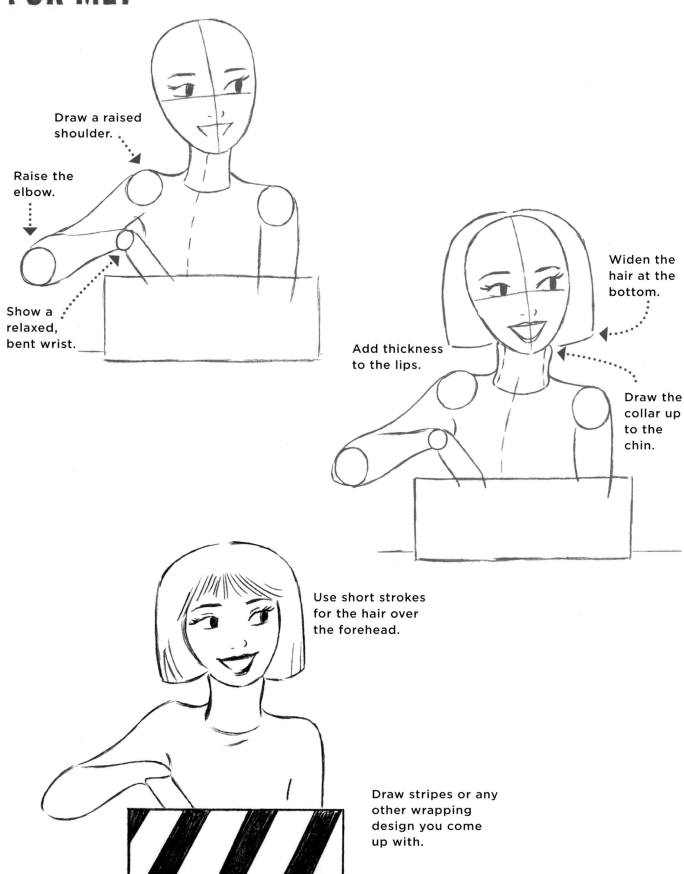

Draw a raised shoulder.

Raise the elbow.

Show a relaxed, bent wrist.

Widen the hair at the bottom.

Add thickness to the lips.

Draw the collar up to the chin.

Use short strokes for the hair over the forehead.

Draw stripes or any other wrapping design you come up with.

A SUMMER BREEZE

When two figures are drawn in silhouette, you rely on their postures to communicate feelings.

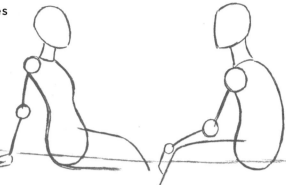

In contrast to the woman's posture, the man leans forward and rests his elbows on his legs.

The weight of the woman's upper body is propped up by her arms, which are locked.

Make It Your Own

If you'd like to create a scene out of this, add a few more boats to the foreground or background, and draw a lighthouse or some picturesque cliffs behind them.

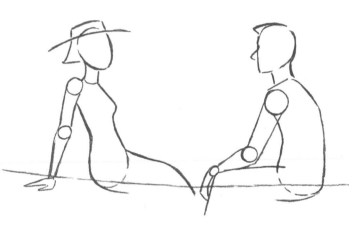

You don't need to use more detail than you see here. At this stage, you should make any changes you think are necessary.

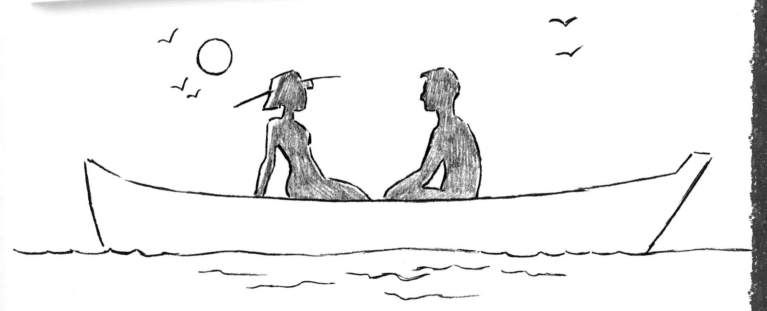

DEEJAY

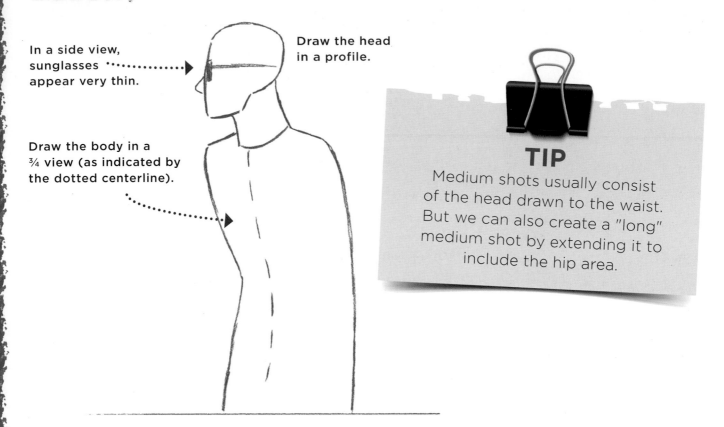

In a side view, sunglasses appear very thin.

Draw the head in a profile.

Draw the body in a ¾ view (as indicated by the dotted centerline).

TIP

Medium shots usually consist of the head drawn to the waist. But we can also create a "long" medium shot by extending it to include the hip area.

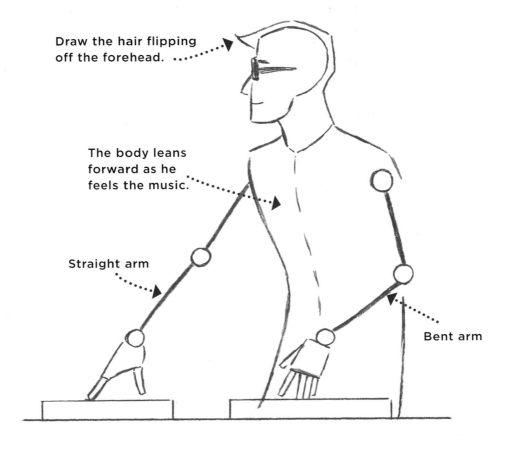

Draw the hair flipping off the forehead.

The body leans forward as he feels the music.

Straight arm

Bent arm

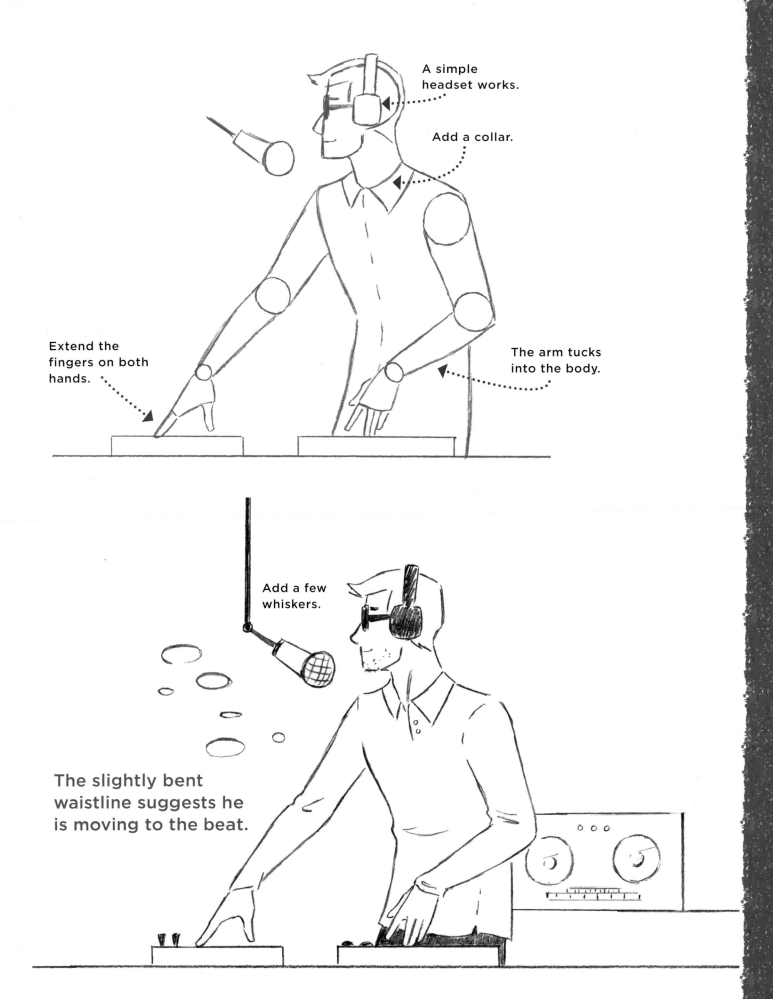

WOMAN WITH TOTE BAG

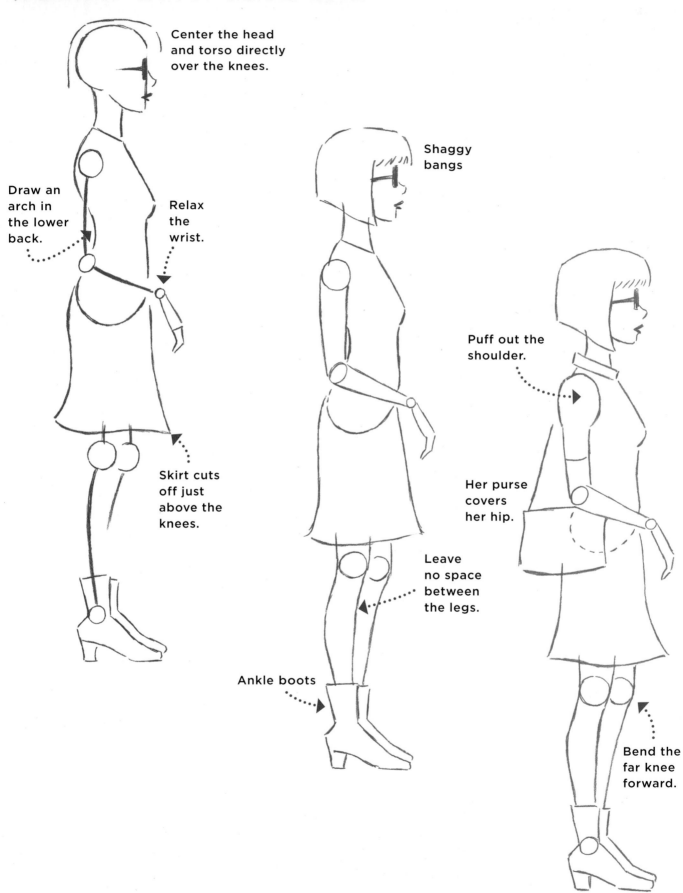

Center the head and torso directly over the knees.

Draw an arch in the lower back.

Relax the wrist.

Skirt cuts off just above the knees.

Shaggy bangs

Ankle boots

Leave no space between the legs.

Puff out the shoulder.

Her purse covers her hip.

Bend the far knee forward.

Add a few lines to the hair for definition.

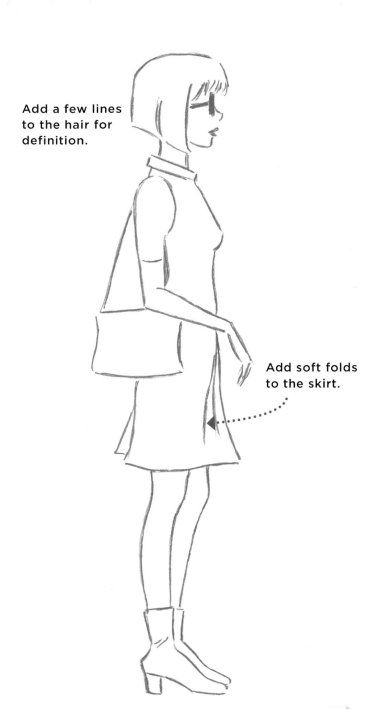

Add soft folds to the skirt.

Make It Your Own

You can create texture and different tones by using light, medium, or dark shading.

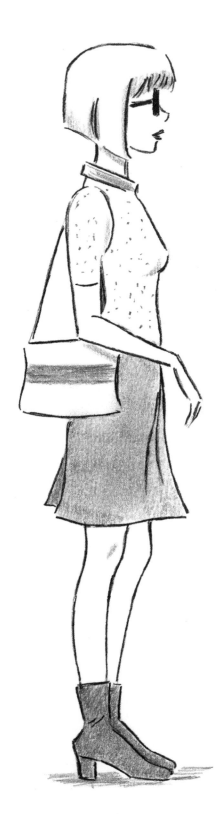

BOMBER JACKET

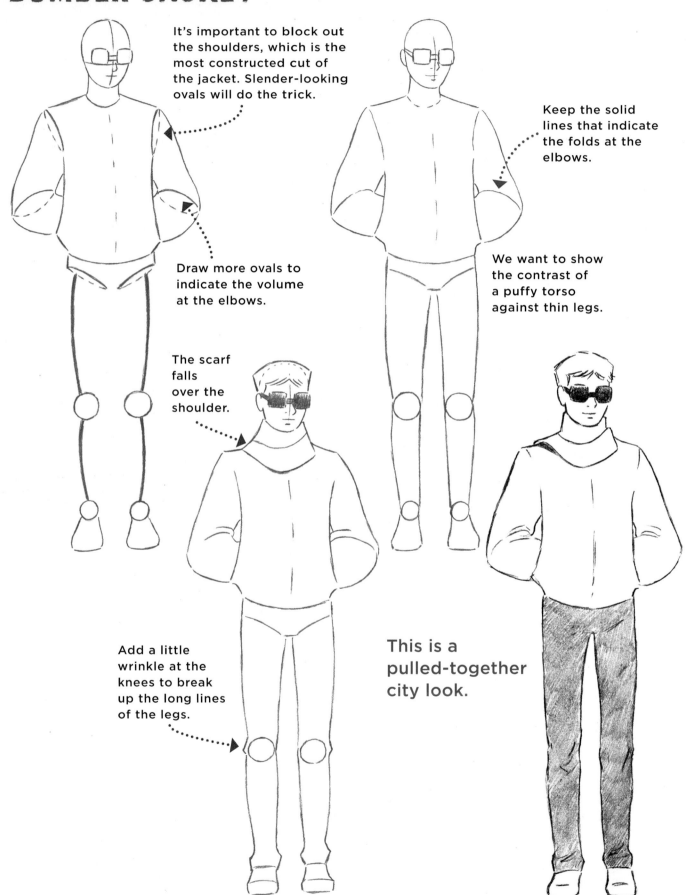

It's important to block out the shoulders, which is the most constructed cut of the jacket. Slender-looking ovals will do the trick.

Draw more ovals to indicate the volume at the elbows.

Keep the solid lines that indicate the folds at the elbows.

We want to show the contrast of a puffy torso against thin legs.

The scarf falls over the shoulder.

Add a little wrinkle at the knees to break up the long lines of the legs.

This is a pulled-together city look.

WINDBREAKER

Draw the brim of the cap facing left.

The centerline (dotted line) shows him in a ¾ view.

The body hides a portion of the arm.

Drawing the hands in the pockets indicates a casual stroll.

The foot doesn't need to come very far off the ground.

To show the effect of wind, draw the scarf aloft.

A rolled-up newspaper is basically a cylinder.

Bent arms will cause folds and creases to appear at the elbows.

TEAM SLEDDING

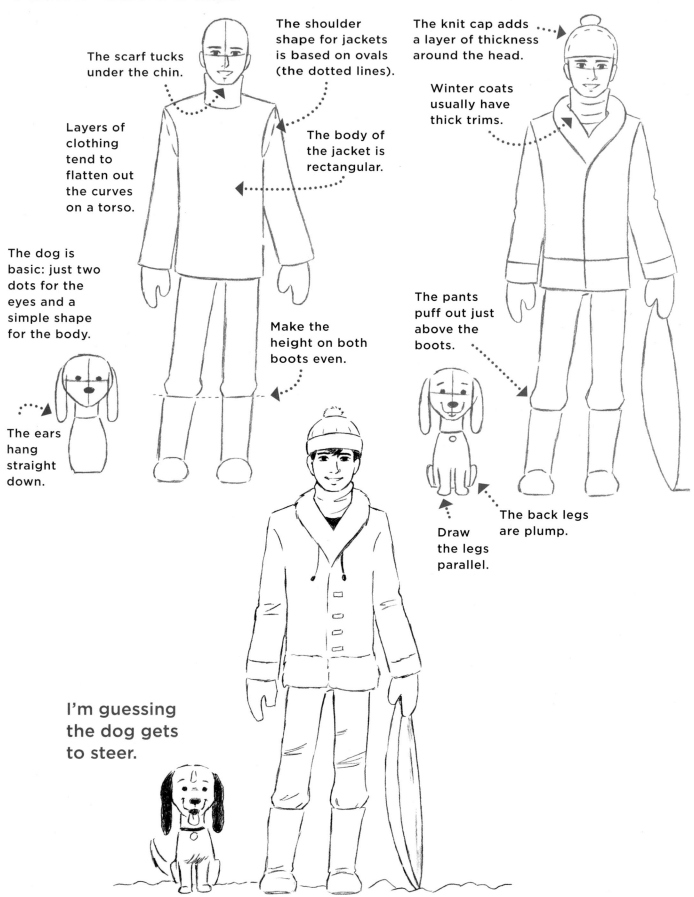

The scarf tucks under the chin.

The shoulder shape for jackets is based on ovals (the dotted lines).

The knit cap adds a layer of thickness around the head.

Winter coats usually have thick trims.

Layers of clothing tend to flatten out the curves on a torso.

The body of the jacket is rectangular.

The dog is basic: just two dots for the eyes and a simple shape for the body.

Make the height on both boots even.

The pants puff out just above the boots.

The ears hang straight down.

Draw the legs parallel.

The back legs are plump.

I'm guessing the dog gets to steer.

LYING ON ONE SIDE

The various sections of the body are unified by a flowing line.

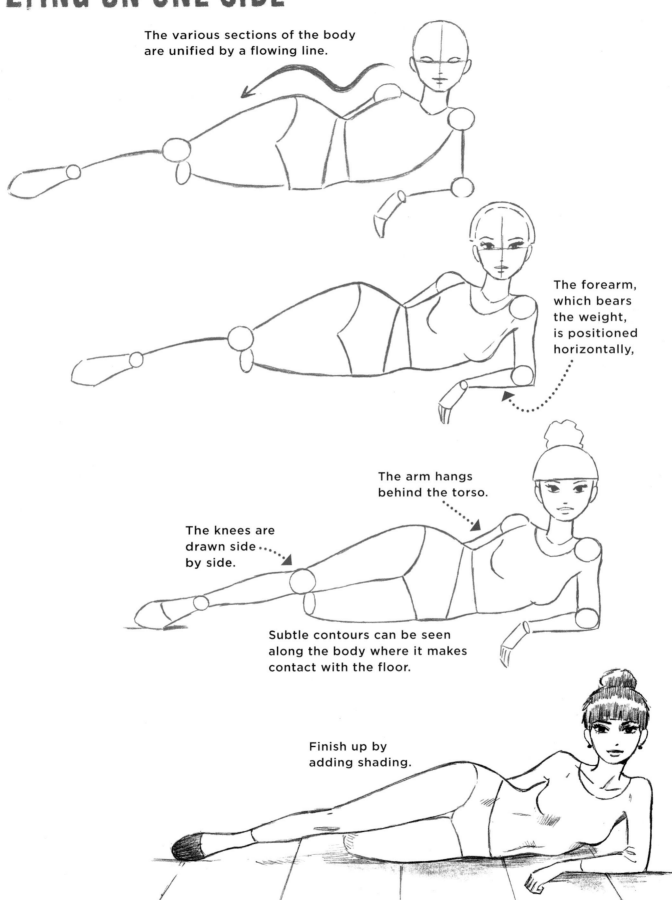

The forearm, which bears the weight, is positioned horizontally,

The arm hangs behind the torso.

The knees are drawn side by side.

Subtle contours can be seen along the body where it makes contact with the floor.

Finish up by adding shading.

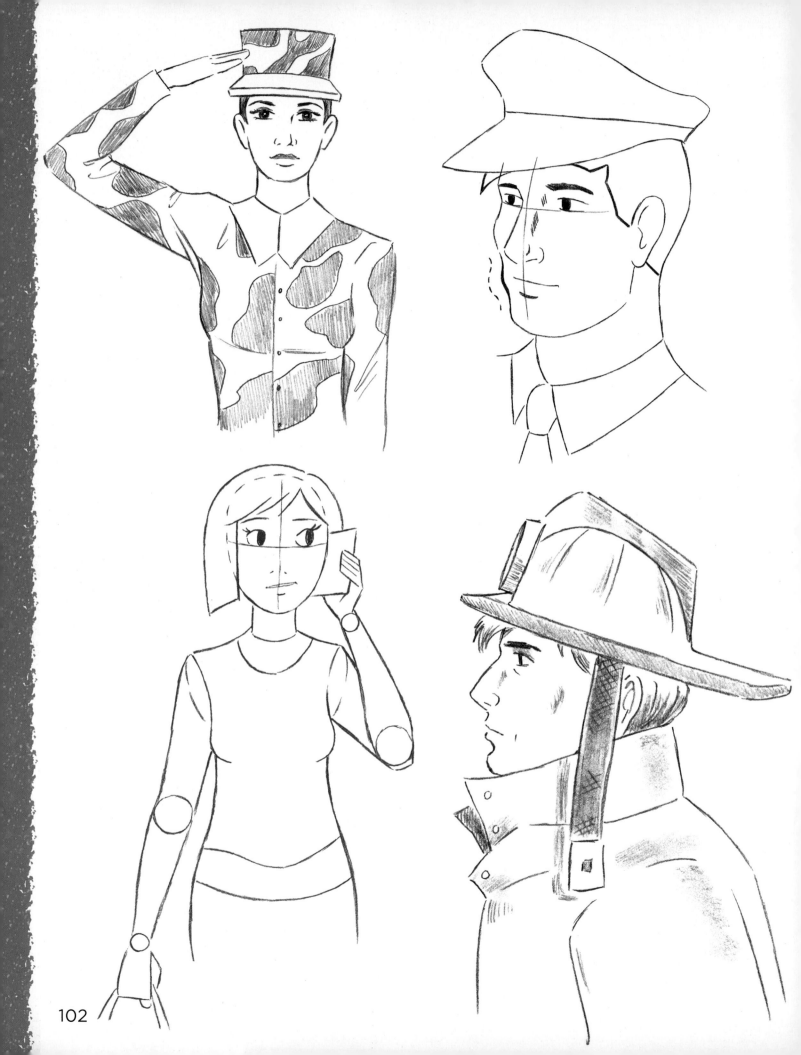

EVERYDAY HEROES

Everybody loves a hero. Some are rugged and brave, like soldiers and firefighters. Others show their courage in a quieter way, like a person who sticks by a friend through difficult times. They all have their own special qualities, which we can use to create compelling drawings.

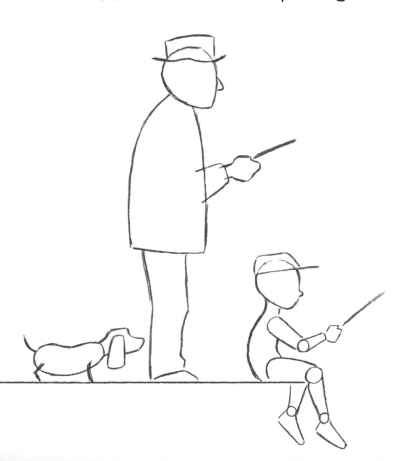

SOLDIER

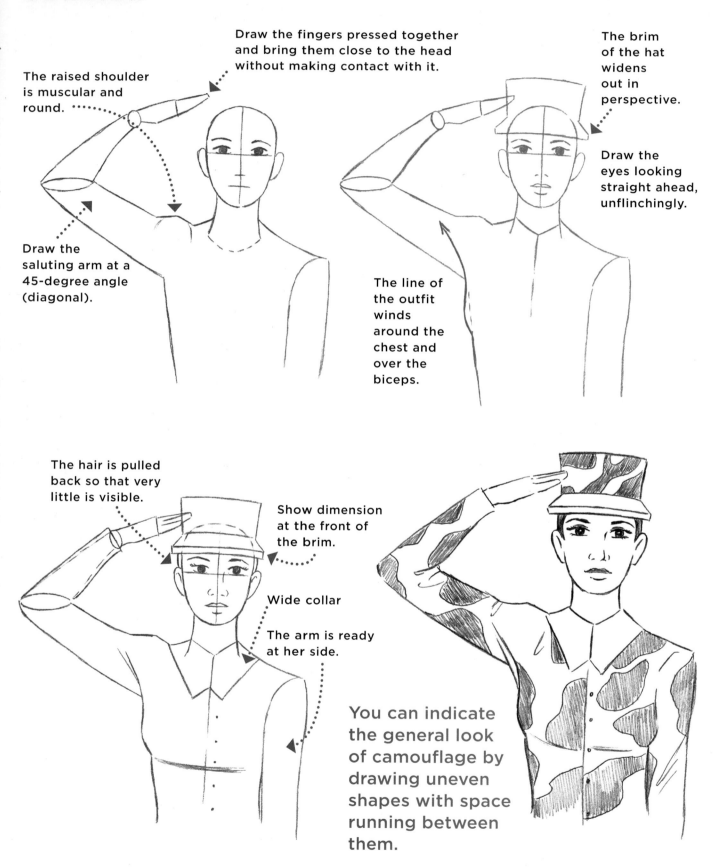

The raised shoulder is muscular and round.

Draw the fingers pressed together and bring them close to the head without making contact with it.

Draw the saluting arm at a 45-degree angle (diagonal).

The brim of the hat widens out in perspective.

Draw the eyes looking straight ahead, unflinchingly.

The line of the outfit winds around the chest and over the biceps.

The hair is pulled back so that very little is visible.

Show dimension at the front of the brim.

Wide collar

The arm is ready at her side.

You can indicate the general look of camouflage by drawing uneven shapes with space running between them.

ER DOCTOR

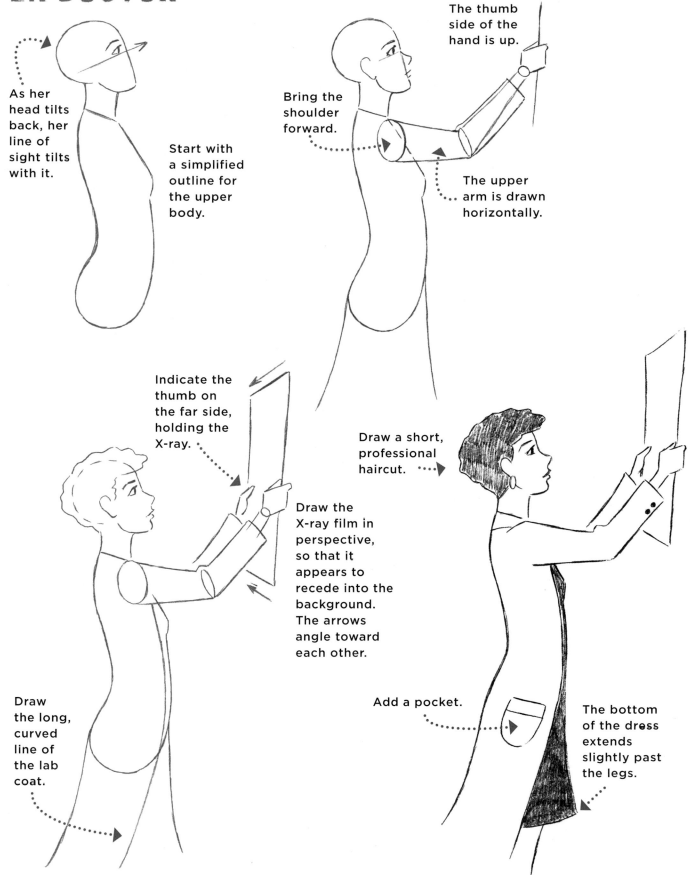

As her head tilts back, her line of sight tilts with it.

Start with a simplified outline for the upper body.

The thumb side of the hand is up.

Bring the shoulder forward.

The upper arm is drawn horizontally.

Indicate the thumb on the far side, holding the X-ray.

Draw a short, professional haircut.

Draw the X-ray film in perspective, so that it appears to recede into the background. The arrows angle toward each other.

Draw the long, curved line of the lab coat.

Add a pocket.

The bottom of the dress extends slightly past the legs.

FIREFIGHTER

Draw the eyebrow farther forward than the eye.

Draw a square jaw.

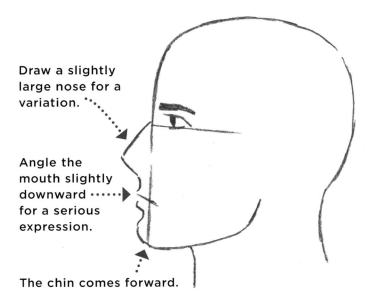

Draw a slightly large nose for a variation.

Angle the mouth slightly downward for a serious expression.

The chin comes forward.

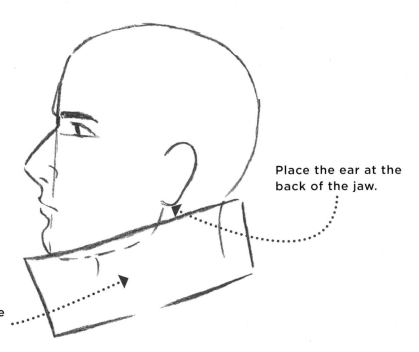

Place the ear at the back of the jaw.

The high collar hides the neck as well as part of the jaw (dotted line).

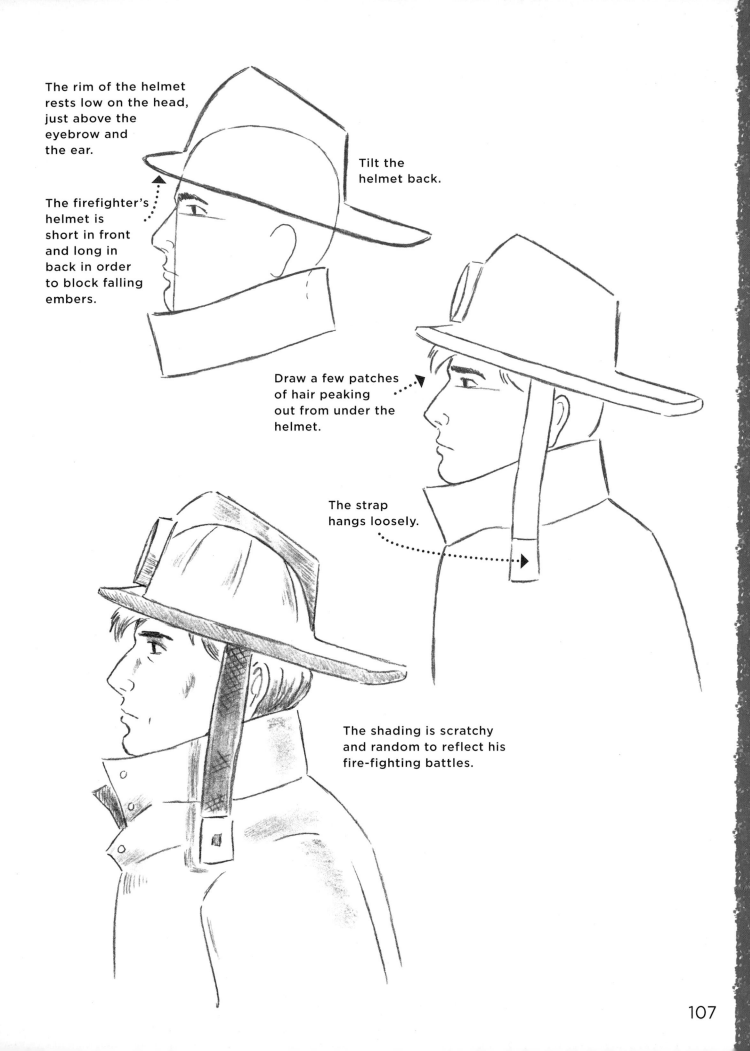

The rim of the helmet rests low on the head, just above the eyebrow and the ear.

The firefighter's helmet is short in front and long in back in order to block falling embers.

Tilt the helmet back.

Draw a few patches of hair peaking out from under the helmet.

The strap hangs loosely.

The shading is scratchy and random to reflect his fire-fighting battles.

LAW ENFORCEMENT

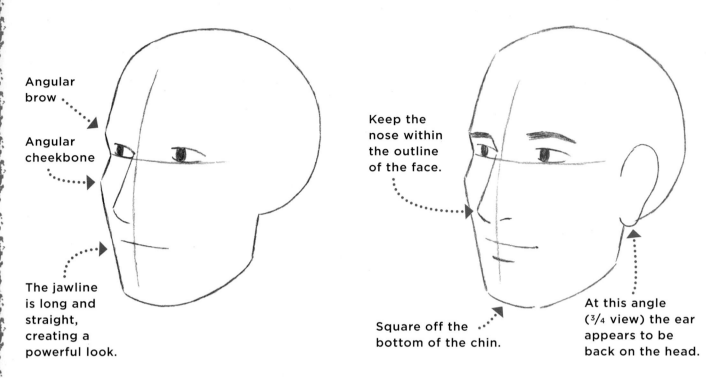

Angular brow

Angular cheekbone

The jawline is long and straight, creating a powerful look.

Keep the nose within the outline of the face.

Square off the bottom of the chin.

At this angle (³/₄ view) the ear appears to be back on the head.

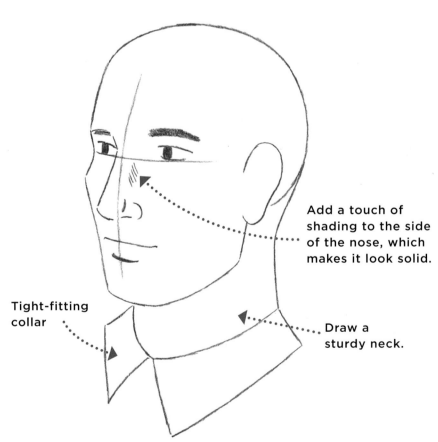

Add a touch of shading to the side of the nose, which makes it look solid.

Tight-fitting collar

Draw a sturdy neck.

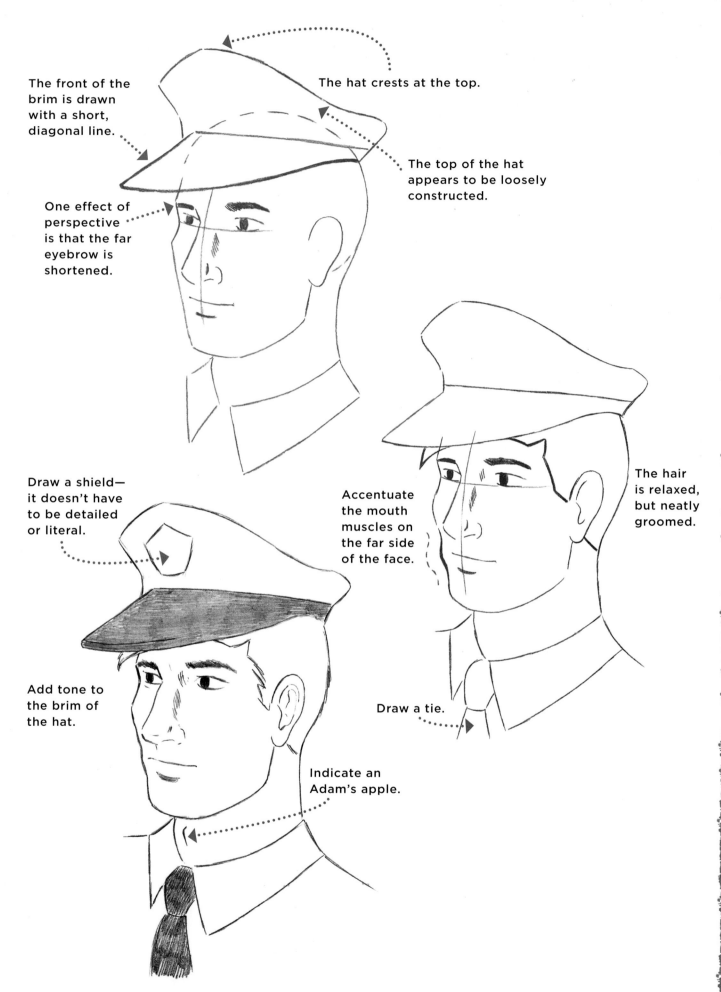

The front of the
brim is drawn
with a short,
diagonal line.

The hat crests at the top.

The top of the hat
appears to be loosely
constructed.

One effect of
perspective
is that the far
eyebrow is
shortened.

Draw a shield—
it doesn't have
to be detailed
or literal.

Accentuate
the mouth
muscles on
the far side
of the face.

The hair
is relaxed,
but neatly
groomed.

Add tone to
the brim of
the hat.

Draw a tie.

Indicate an
Adam's apple.

109

GRANDPARENTS WHO MAKE THE TIME

Start with the construction of a simplified figure in a side view.

Eliminate the neck and round off the shoulders.

Draw the jacket so it overhangs the legs.

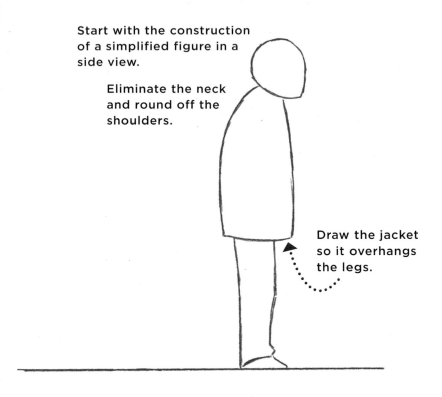

Draw a hat that looks as if it's been stuffed in the back of the dresser.

The hand is thumb side up.

Draw the arm close to the body.

Draw a large, round head and a small body.

The back curves.

Dangle the foot.

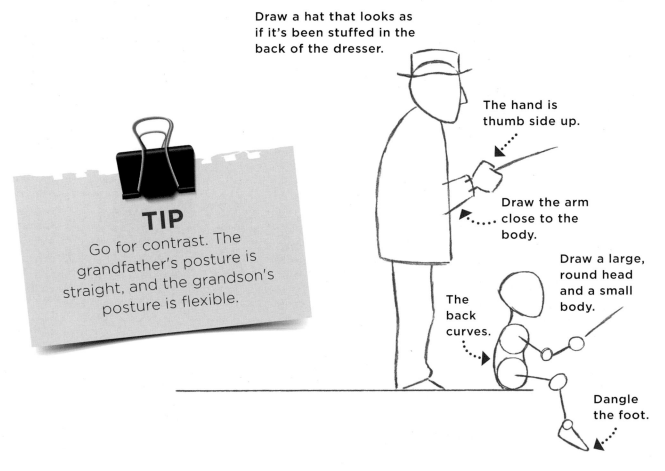

TIP

Go for contrast. The grandfather's posture is straight, and the grandson's posture is flexible.

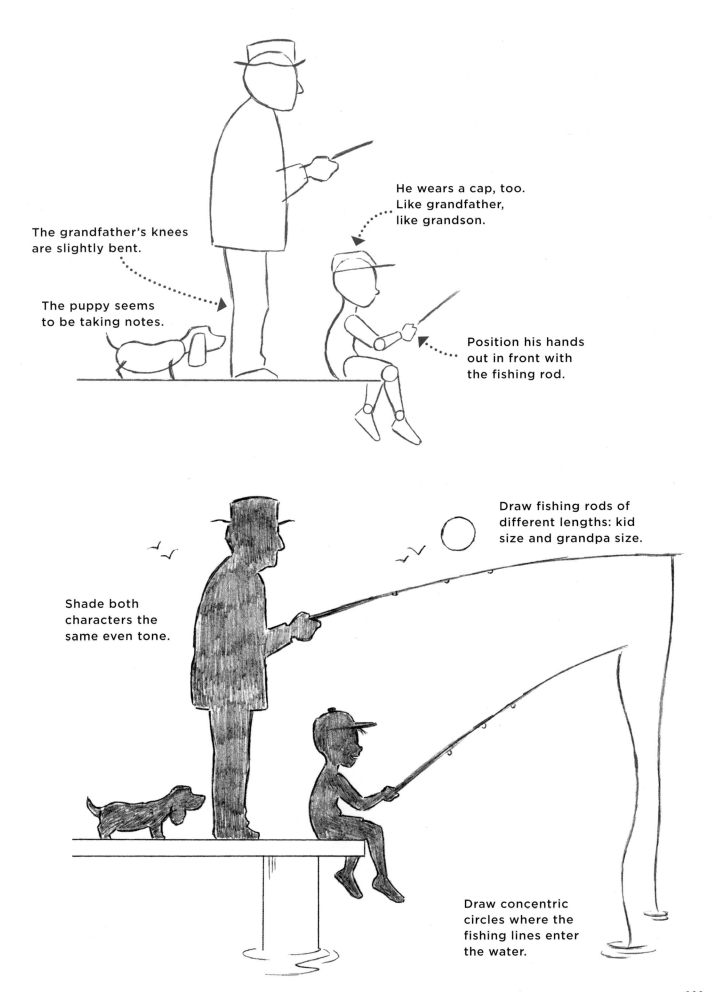

A TRUSTED FRIEND

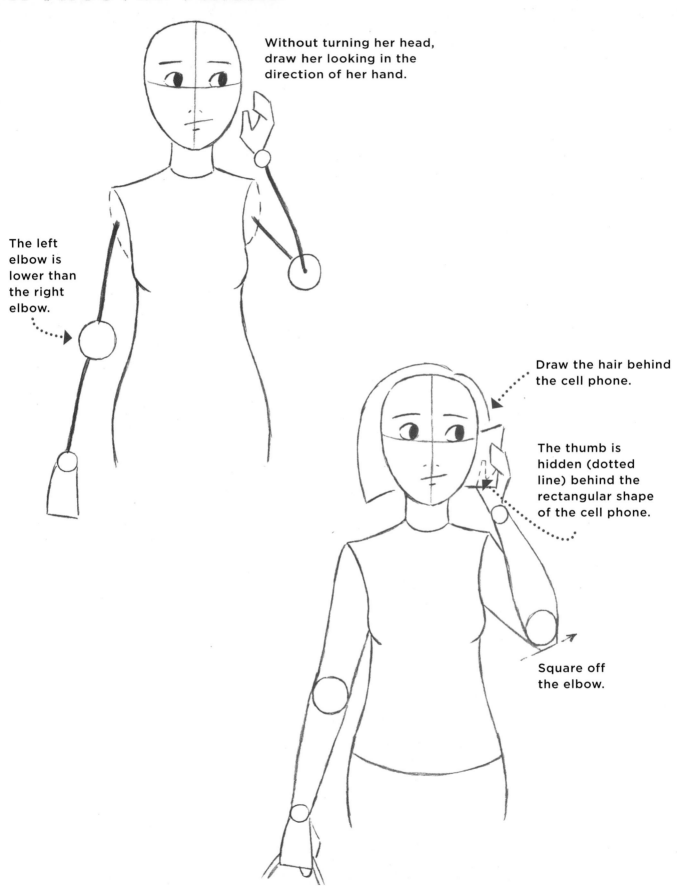

Without turning her head, draw her looking in the direction of her hand.

The left elbow is lower than the right elbow.

Draw the hair behind the cell phone.

The thumb is hidden (dotted line) behind the rectangular shape of the cell phone.

Square off the elbow.

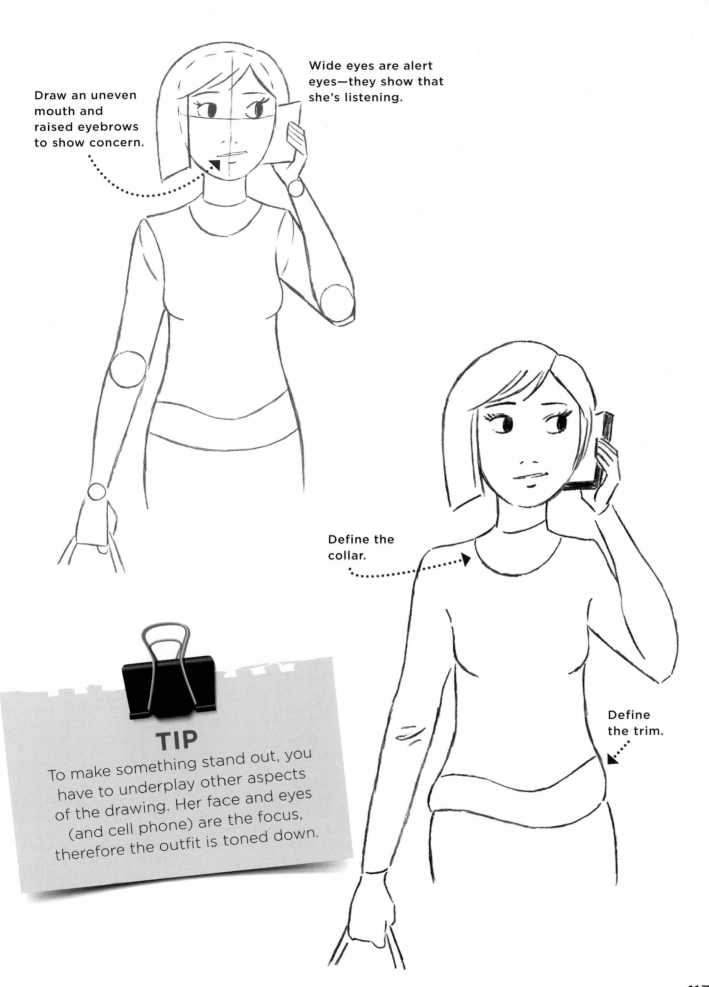

Draw an uneven mouth and raised eyebrows to show concern.

Wide eyes are alert eyes—they show that she's listening.

Define the collar.

Define the trim.

TIP

To make something stand out, you have to underplay other aspects of the drawing. Her face and eyes (and cell phone) are the focus, therefore the outfit is toned down.

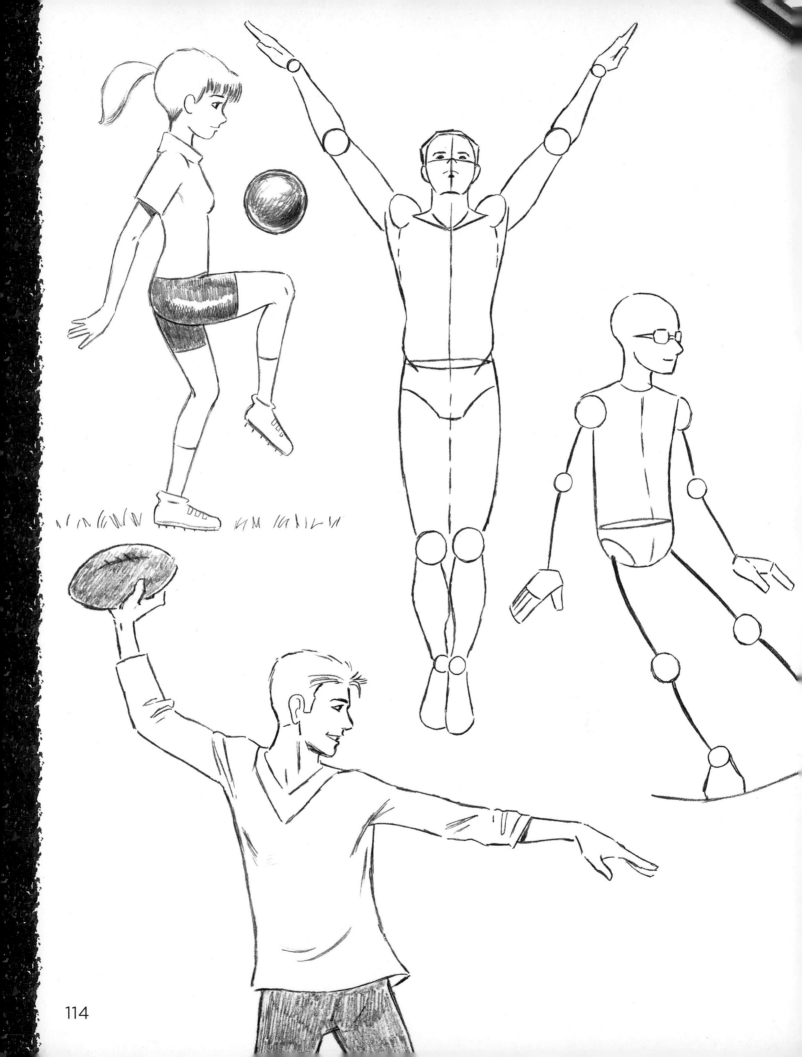

ATHLETES

Athletes make excellent subjects for drawing. They can stretch, twist, and leap—all in a single pose! Drawing them in the middle of an action is like stopping time for an instant. Their physical builds vary according to their sport, providing you with a good range of bodies to practice drawing. You can emphasize strength on a heavier build or speed for a leaner athlete. Let's learn how to draw these dynamic physiques.

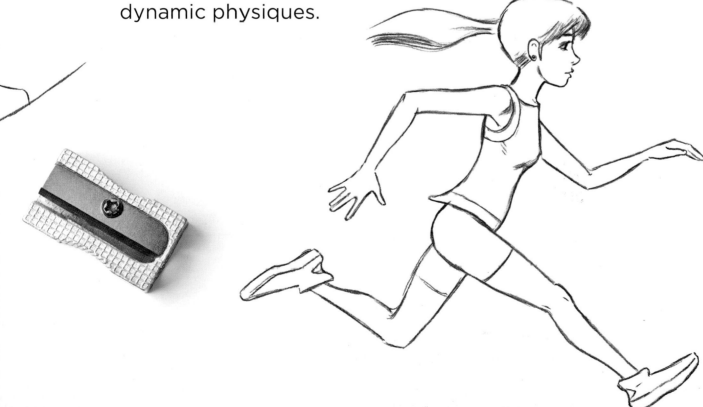

DIVER

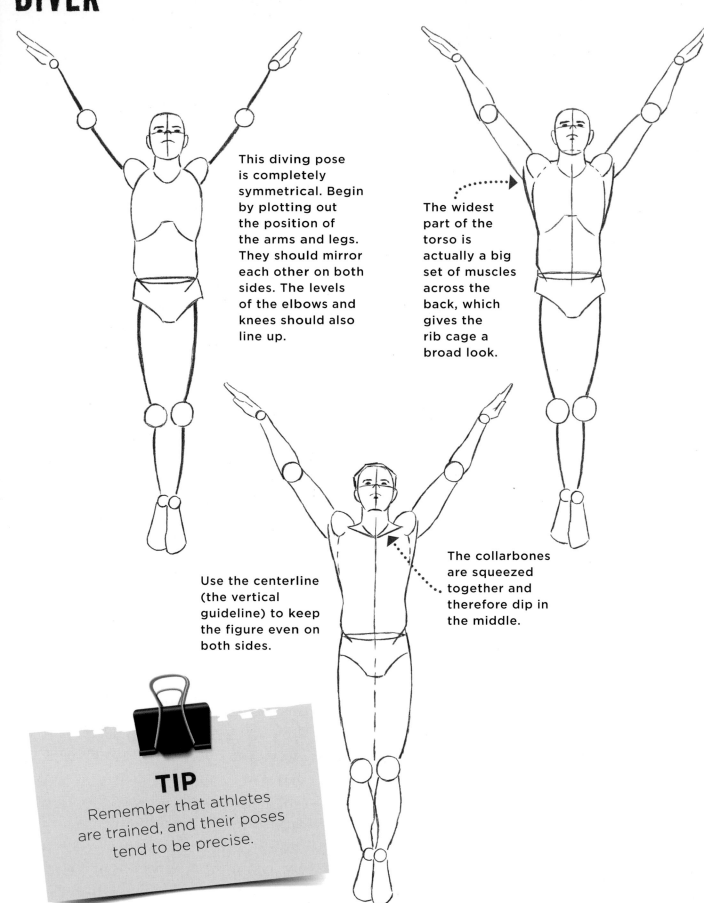

This diving pose is completely symmetrical. Begin by plotting out the position of the arms and legs. They should mirror each other on both sides. The levels of the elbows and knees should also line up.

The widest part of the torso is actually a big set of muscles across the back, which gives the rib cage a broad look.

Use the centerline (the vertical guideline) to keep the figure even on both sides.

The collarbones are squeezed together and therefore dip in the middle.

TIP
Remember that athletes are trained, and their poses tend to be precise.

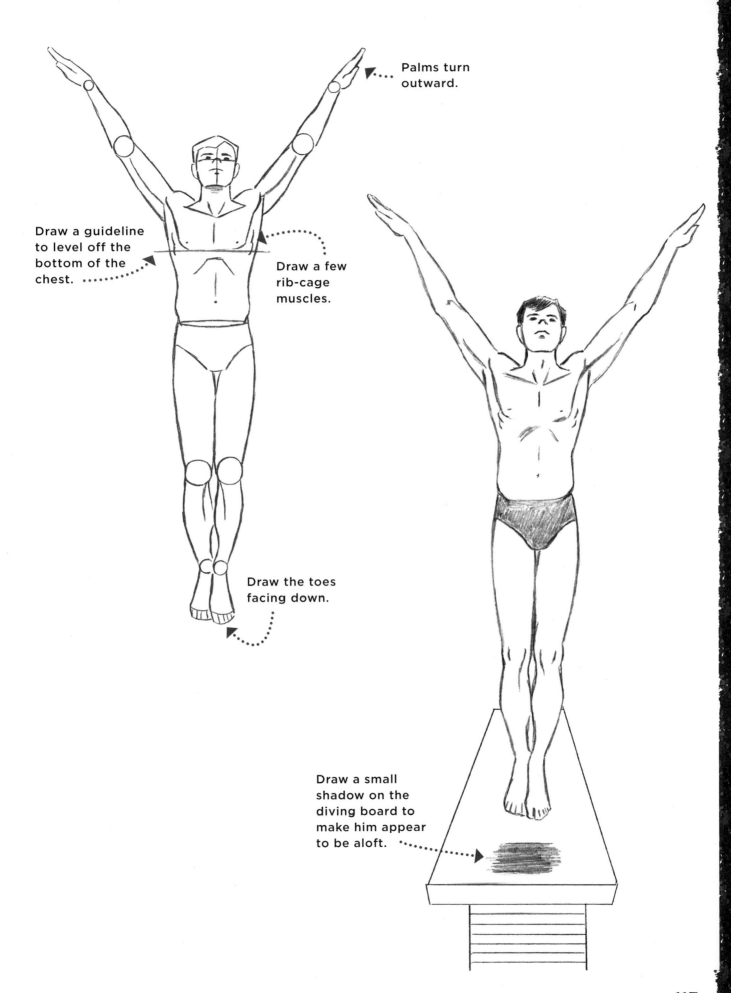

Palms turn outward.

Draw a guideline to level off the bottom of the chest.

Draw a few rib-cage muscles.

Draw the toes facing down.

Draw a small shadow on the diving board to make him appear to be aloft.

SKATEBOARDER

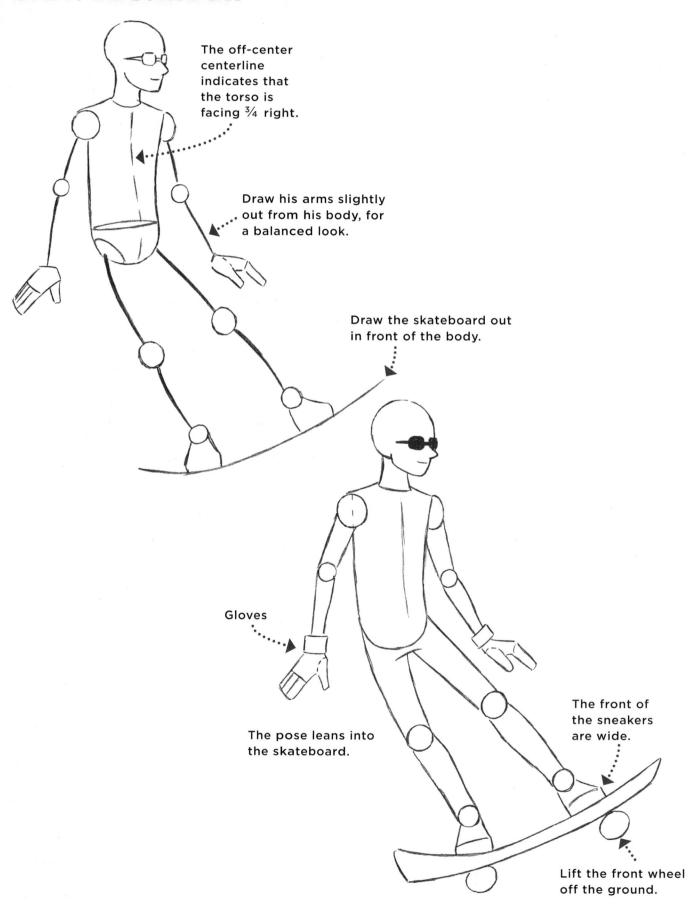

The off-center centerline indicates that the torso is facing ¾ right.

Draw his arms slightly out from his body, for a balanced look.

Draw the skateboard out in front of the body.

Gloves

The pose leans into the skateboard.

The front of the sneakers are wide.

Lift the front wheel off the ground.

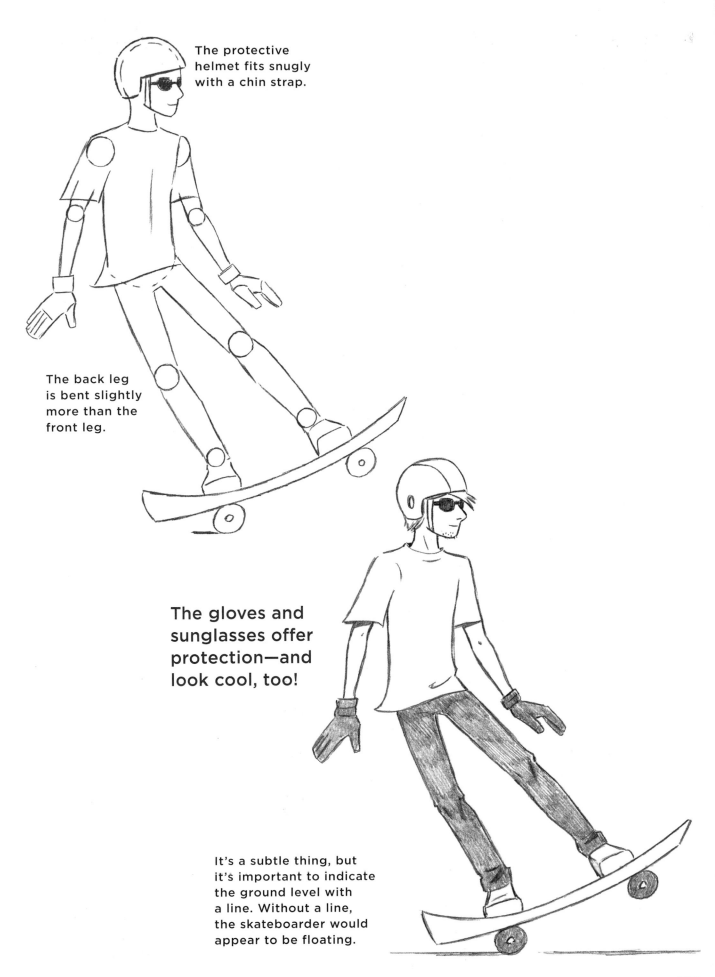

The protective helmet fits snugly with a chin strap.

The back leg is bent slightly more than the front leg.

The gloves and sunglasses offer protection—and look cool, too!

It's a subtle thing, but it's important to indicate the ground level with a line. Without a line, the skateboarder would appear to be floating.

SLUGGER

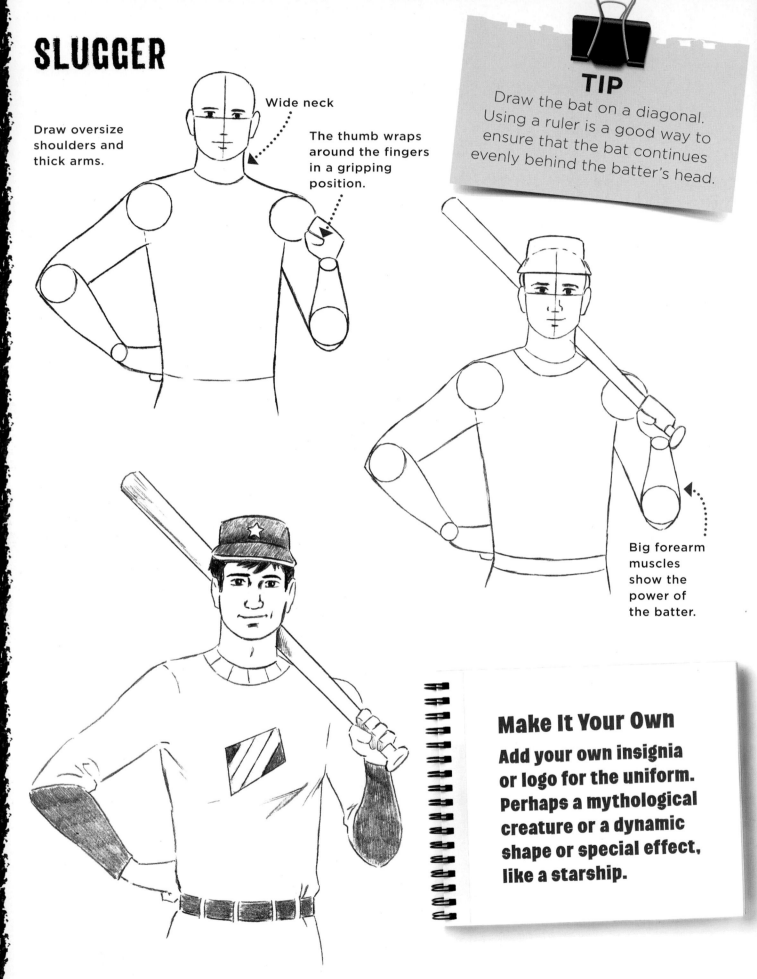

Draw oversize shoulders and thick arms.

Wide neck

The thumb wraps around the fingers in a gripping position.

TIP
Draw the bat on a diagonal. Using a ruler is a good way to ensure that the bat continues evenly behind the batter's head.

Big forearm muscles show the power of the batter.

Make It Your Own

Add your own insignia or logo for the uniform. Perhaps a mythological creature or a dynamic shape or special effect, like a starship.

WEEKEND WARRIOR

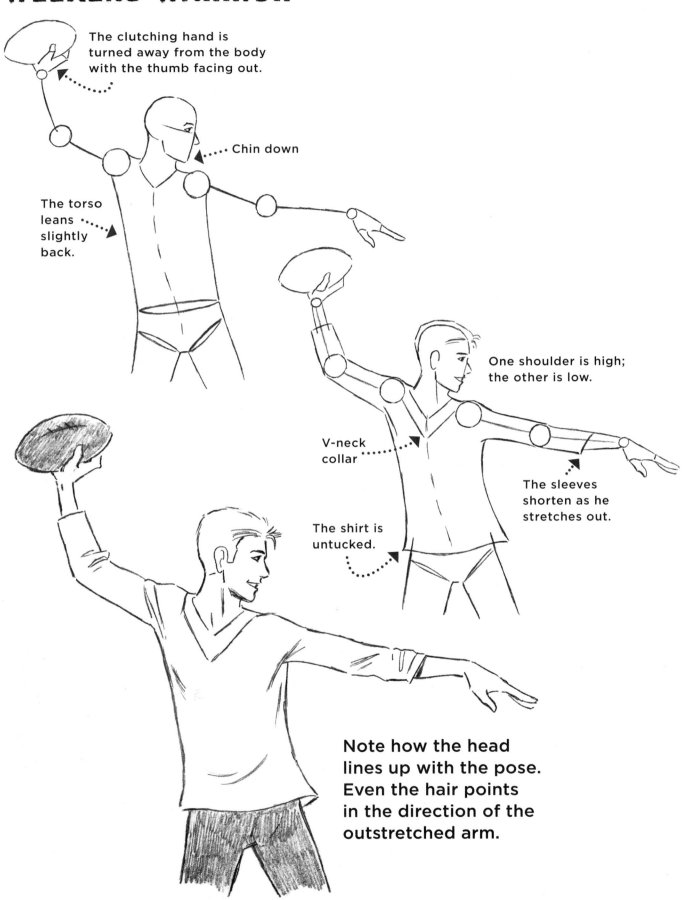

The clutching hand is turned away from the body with the thumb facing out.

Chin down

The torso leans slightly back.

One shoulder is high; the other is low.

V-neck collar

The sleeves shorten as he stretches out.

The shirt is untucked.

Note how the head lines up with the pose. Even the hair points in the direction of the outstretched arm.

SOCCER PLAYER

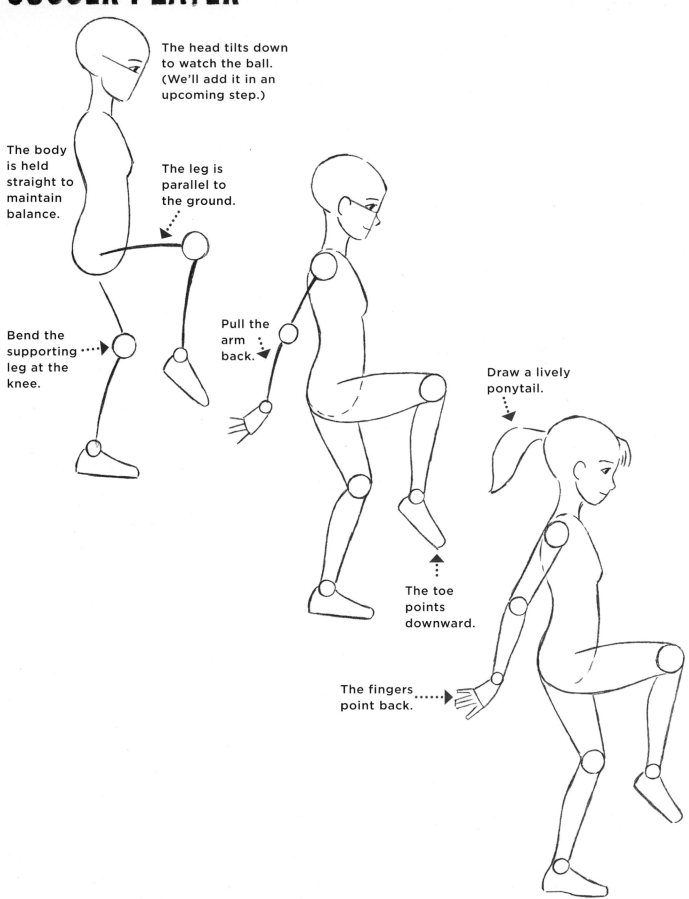

The head tilts down to watch the ball. (We'll add it in an upcoming step.)

The body is held straight to maintain balance.

The leg is parallel to the ground.

Bend the supporting leg at the knee.

Pull the arm back.

The toe points downward.

Draw a lively ponytail.

The fingers point back.

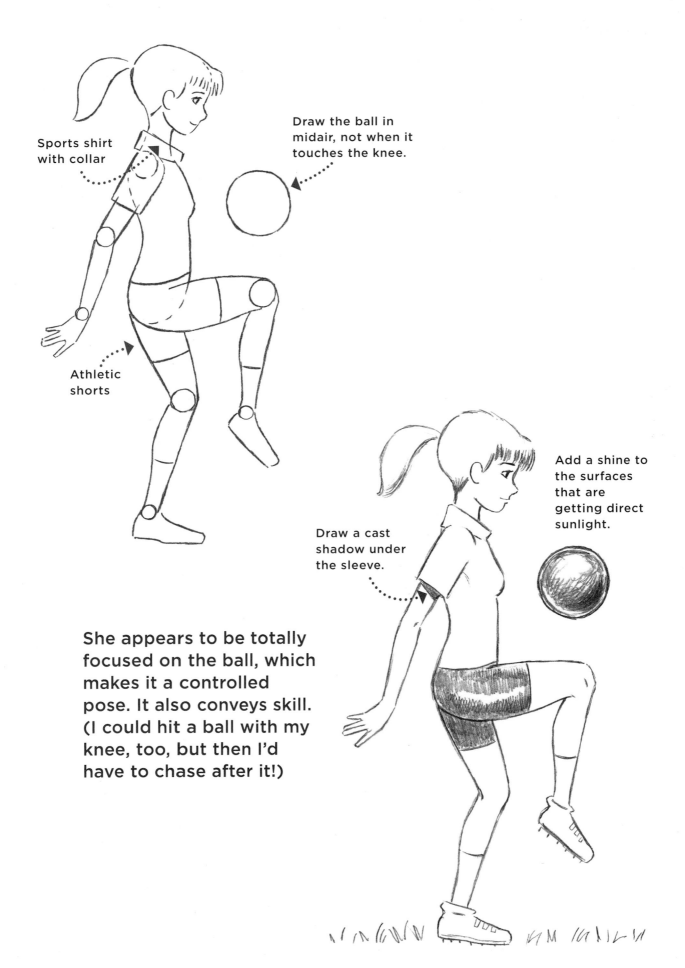

Sports shirt with collar

Draw the ball in midair, not when it touches the knee.

Athletic shorts

Add a shine to the surfaces that are getting direct sunlight.

Draw a cast shadow under the sleeve.

She appears to be totally focused on the ball, which makes it a controlled pose. It also conveys skill. (I could hit a ball with my knee, too, but then I'd have to chase after it!)

FENCER

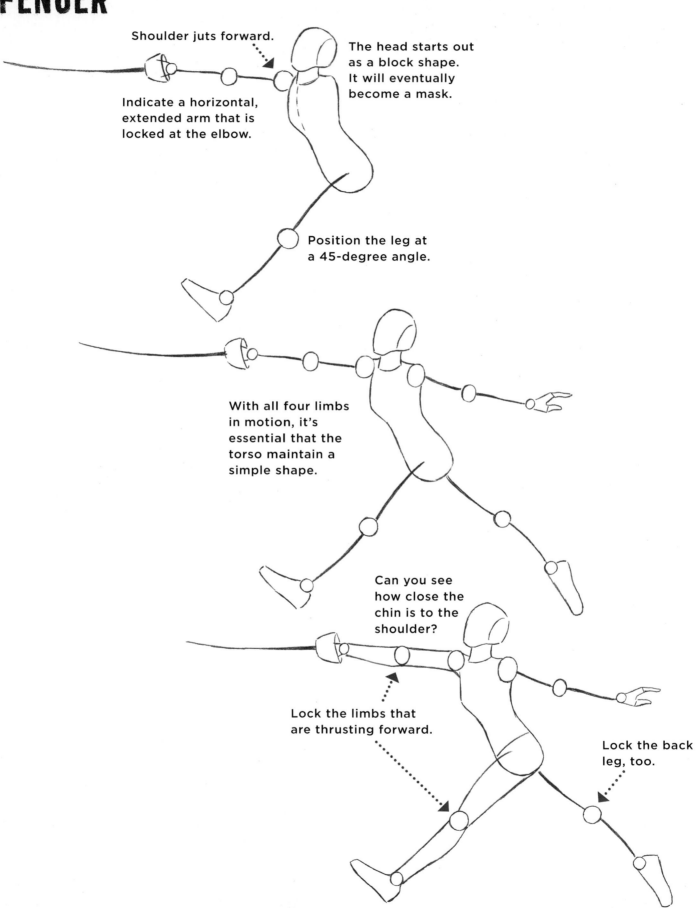

Shoulder juts forward.

The head starts out as a block shape. It will eventually become a mask.

Indicate a horizontal, extended arm that is locked at the elbow.

Position the leg at a 45-degree angle.

With all four limbs in motion, it's essential that the torso maintain a simple shape.

Can you see how close the chin is to the shoulder?

Lock the limbs that are thrusting forward.

Lock the back leg, too.

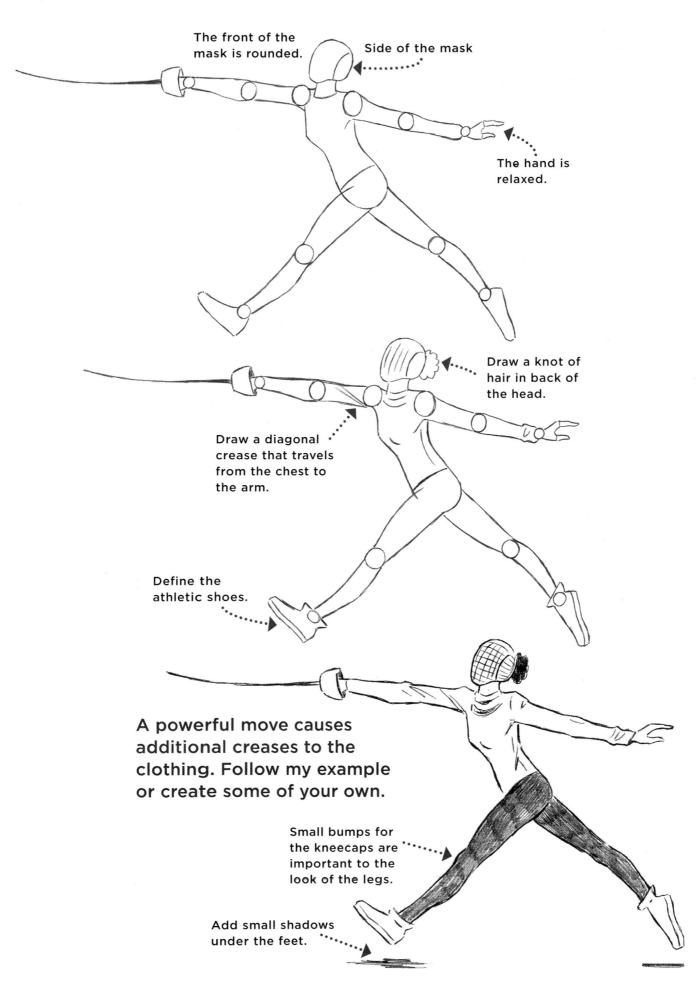

The front of the mask is rounded.

Side of the mask

The hand is relaxed.

Draw a knot of hair in back of the head.

Draw a diagonal crease that travels from the chest to the arm.

Define the athletic shoes.

A powerful move causes additional creases to the clothing. Follow my example or create some of your own.

Small bumps for the kneecaps are important to the look of the legs.

Add small shadows under the feet.

RUNNER

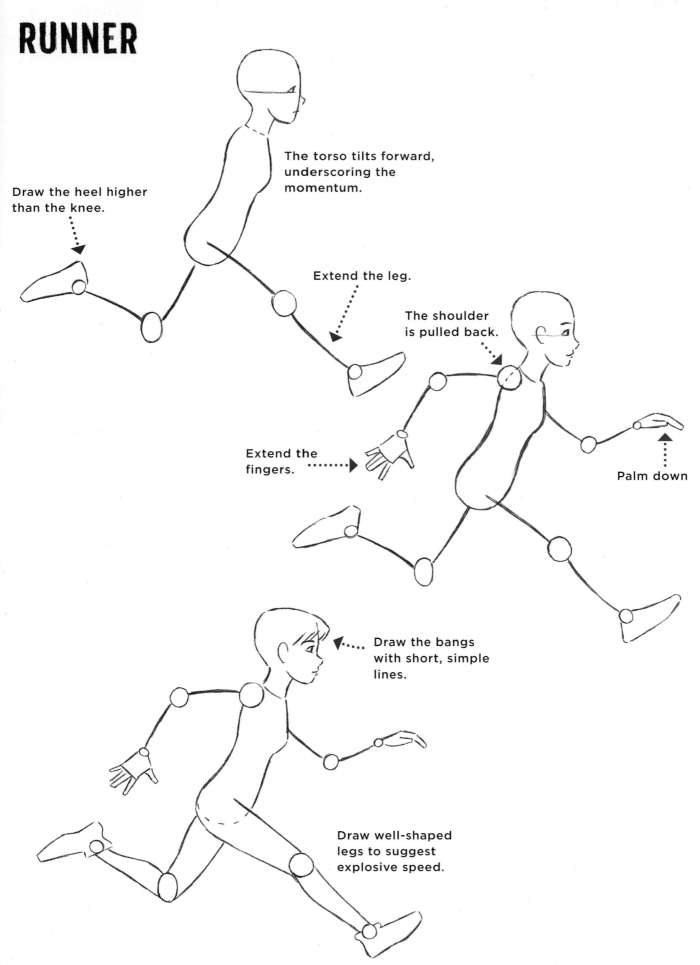

Draw the heel higher than the knee.

The torso tilts forward, underscoring the momentum.

Extend the leg.

The shoulder is pulled back.

Extend the fingers.

Palm down

Draw the bangs with short, simple lines.

Draw well-shaped legs to suggest explosive speed.

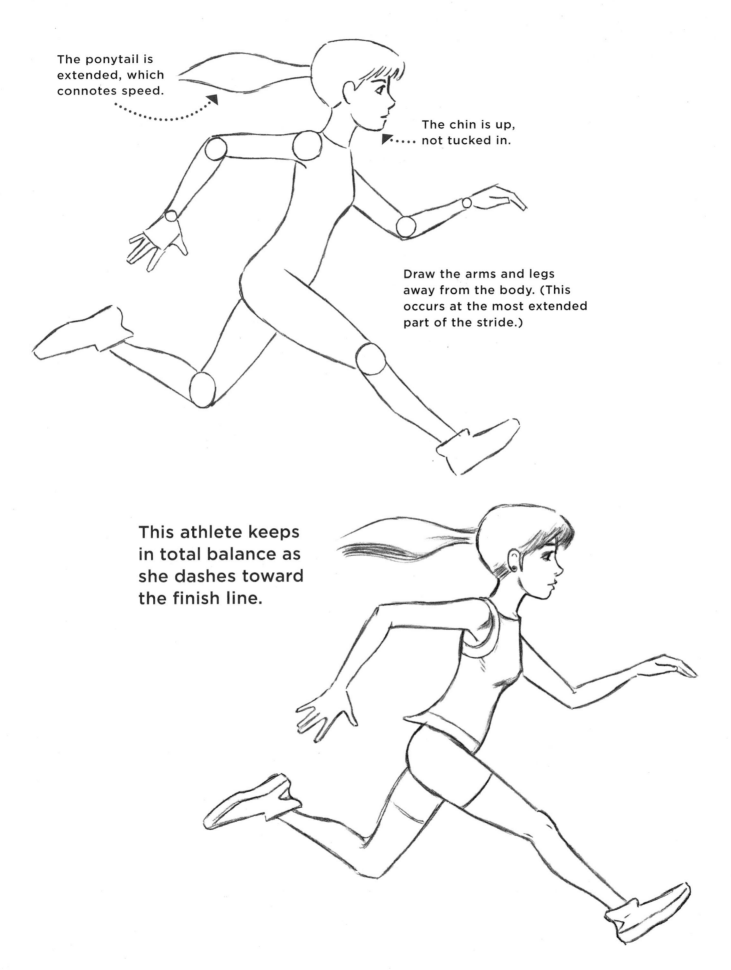

The ponytail is extended, which connotes speed.

The chin is up, not tucked in.

Draw the arms and legs away from the body. (This occurs at the most extended part of the stride.)

This athlete keeps in total balance as she dashes toward the finish line.

DRAWING CHALLENGE

Up to this point, you've followed numerous step-by-step illustrations to complete each drawing. Now let's take it one step further. For each figure in this chapter, I've created a single, detailed construction step instead of four or five. Analyze the construction before you begin to draw to determine the main thrust of the pose and take note of proportions. Perhaps you would like to modify a pose or change an outfit. Here's your chance to do it.

ASYMMETRICAL POSE

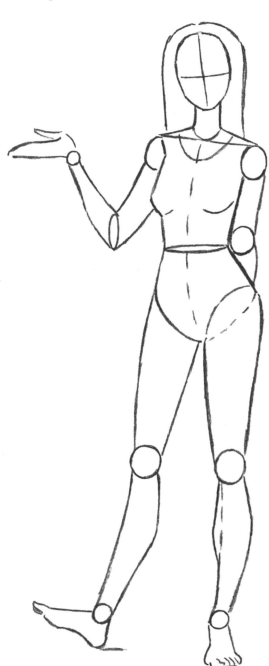

One-Step Detailed Construction

Though it's only one step, it has all the elements of the figure, along with the body dynamics. Focus on the centerline, placement of the joints, the shape of the chest and hips, and the general proportions of the body.

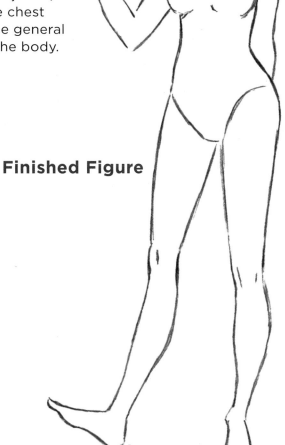

Finished Figure

Practice Page

Pages have been provided for drawing right in the book, enabling you to easily compare your drawing to the one-step construction on the opposite page. You'll have to stretch a little in this section, but a little stretching is good for artists. When we stretch, we improve.

WAVING

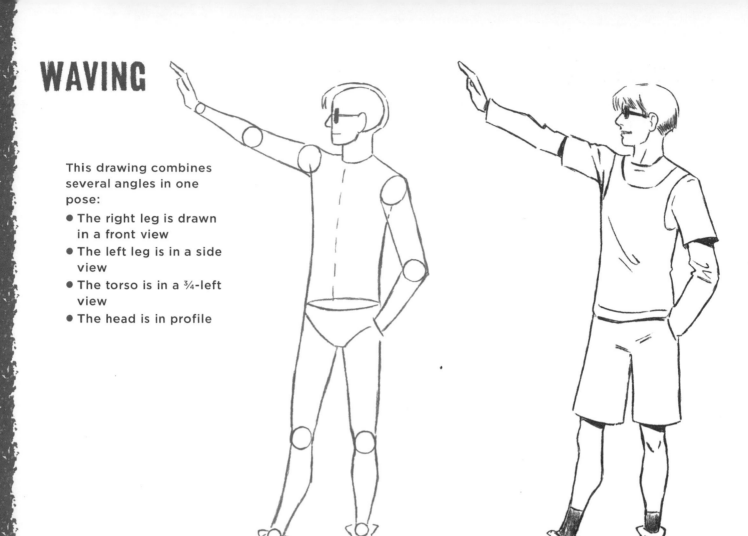

This drawing combines several angles in one pose:

- The right leg is drawn in a front view
- The left leg is in a side view
- The torso is in a ¾-left view
- The head is in profile

LYING TUMMY-SIDE DOWN

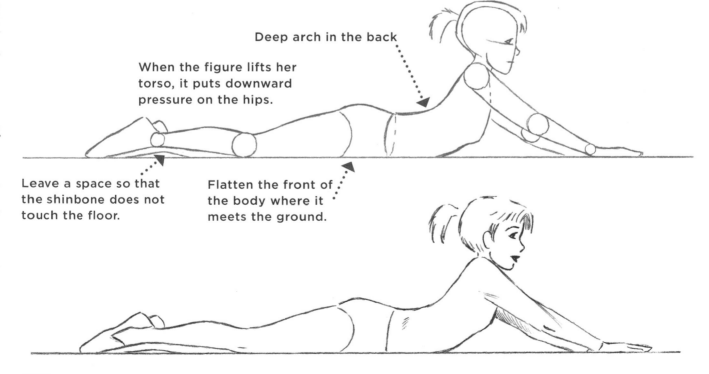

Deep arch in the back

When the figure lifts her torso, it puts downward pressure on the hips.

Leave a space so that the shinbone does not touch the floor.

Flatten the front of the body where it meets the ground.

Practice Page

Use the blank pages in this chapter to practice your final drawings based on the one-step constructions.

BALLET PRACTICE

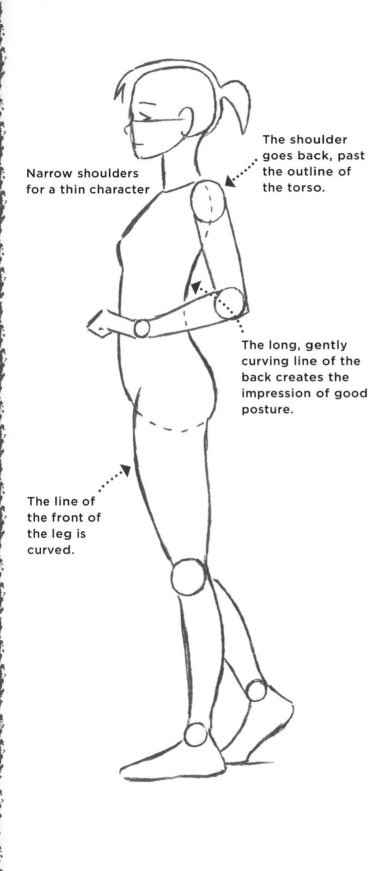

Narrow shoulders for a thin character

The shoulder goes back, past the outline of the torso.

The long, gently curving line of the back creates the impression of good posture.

The line of the front of the leg is curved.

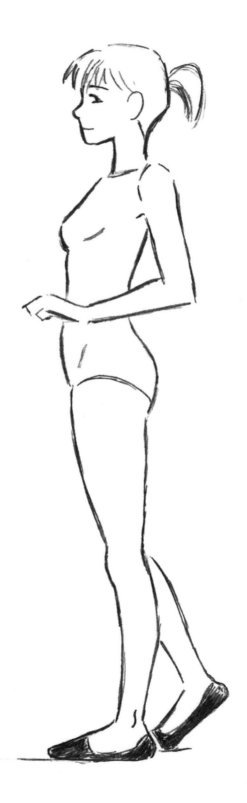

Practice Page

Use the blank pages in this chapter to practice your final drawings based on the one-step constructions.

¾ VIEW—BACK ANGLE

There's a significant slope between the neck and the shoulders.

The torso overlaps the upper arm.

The centerline follows the curves of the back.

The closer knee joint is slightly lower than the far knee.

To be consistent, the closer ankle is slightly lower than the far ankle joint.

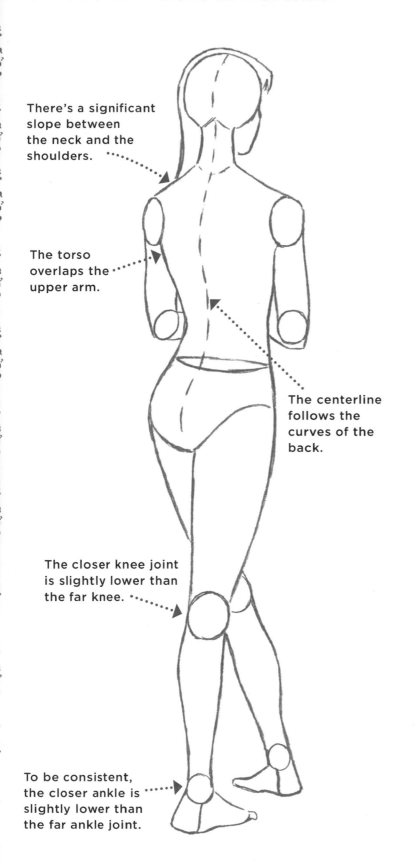
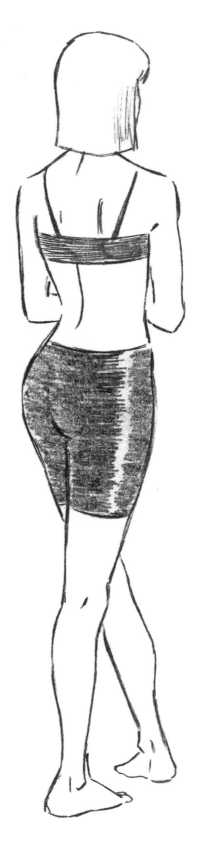

Practice Page

Use the blank pages in this chapter to practice your final drawings based on the one-step constructions.

BUSY DAY

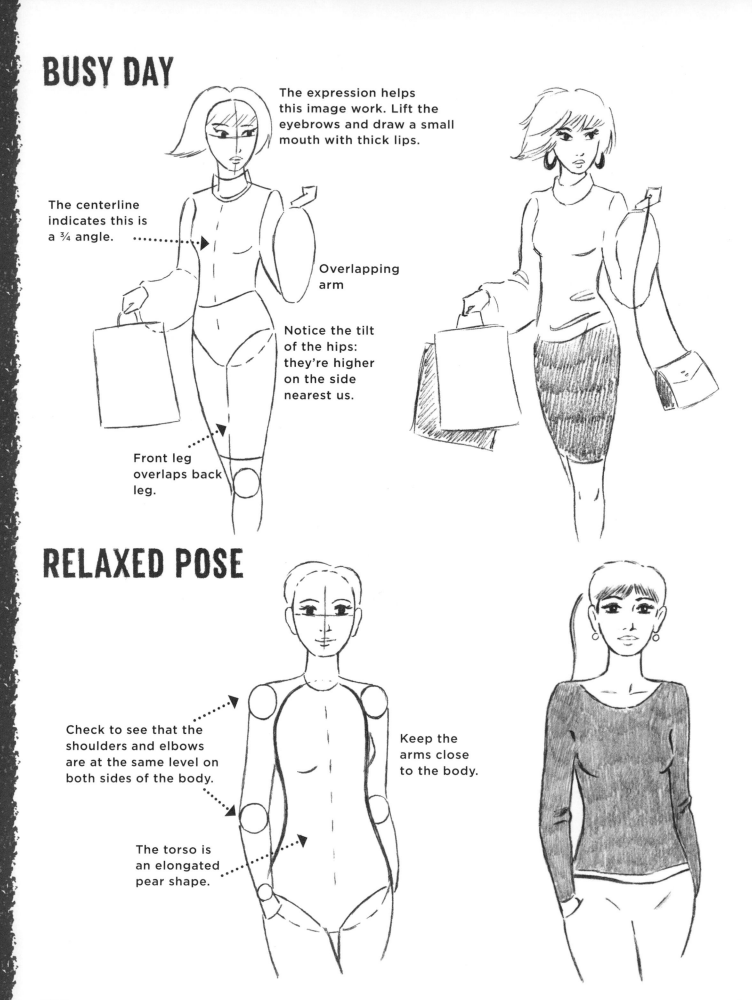

The expression helps this image work. Lift the eyebrows and draw a small mouth with thick lips.

The centerline indicates this is a ¾ angle.

Overlapping arm

Notice the tilt of the hips: they're higher on the side nearest us.

Front leg overlaps back leg.

RELAXED POSE

Check to see that the shoulders and elbows are at the same level on both sides of the body.

Keep the arms close to the body.

The torso is an elongated pear shape.

Practice Page

Use the blank pages in this chapter to practice your final drawings based on the one-step constructions.

WALKING, SIDE VIEW

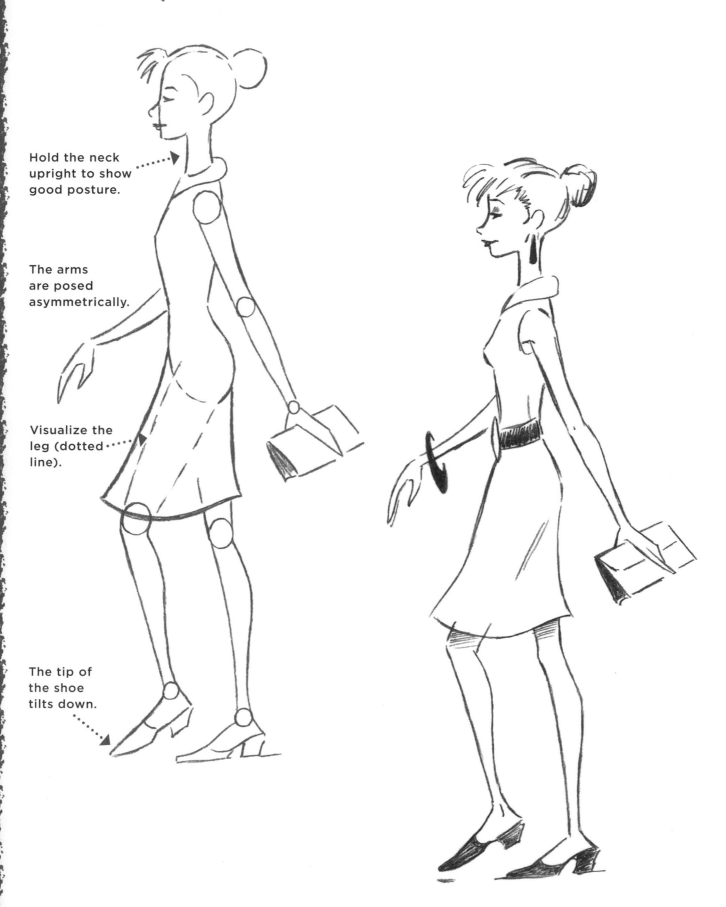

Hold the neck upright to show good posture.

The arms are posed asymmetrically.

Visualize the leg (dotted line).

The tip of the shoe tilts down.

Practice Page

Use the blank pages in this chapter to practice your final drawings based on the one-step constructions.

CROSSED ARMS

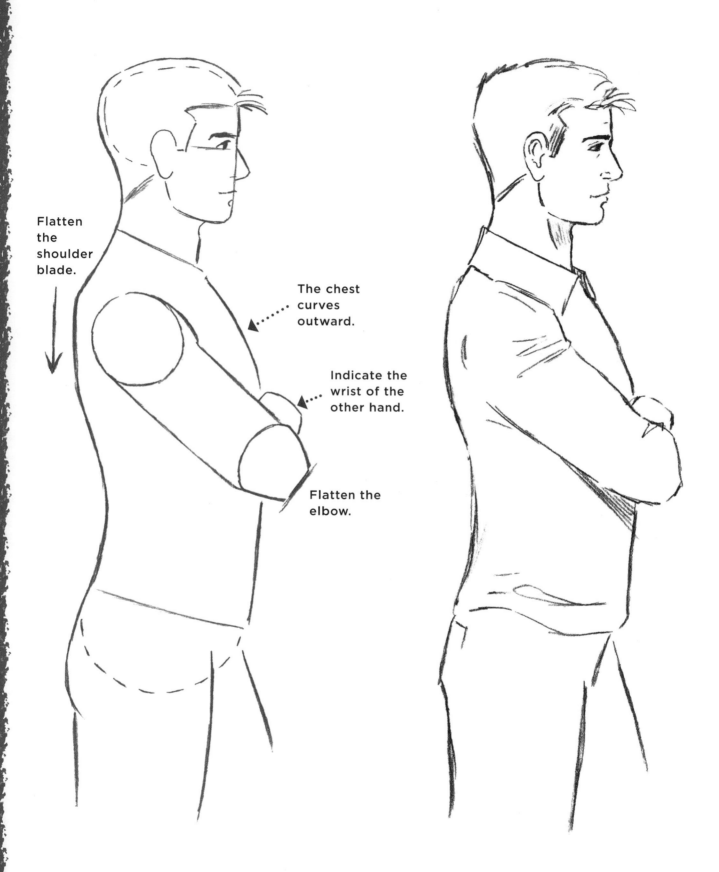

Flatten the shoulder blade.

The chest curves outward.

Indicate the wrist of the other hand.

Flatten the elbow.

Practice Page

Use the blank pages in this chapter to practice your final drawings based on the one-step constructions.

SITTING, SIDE VIEW

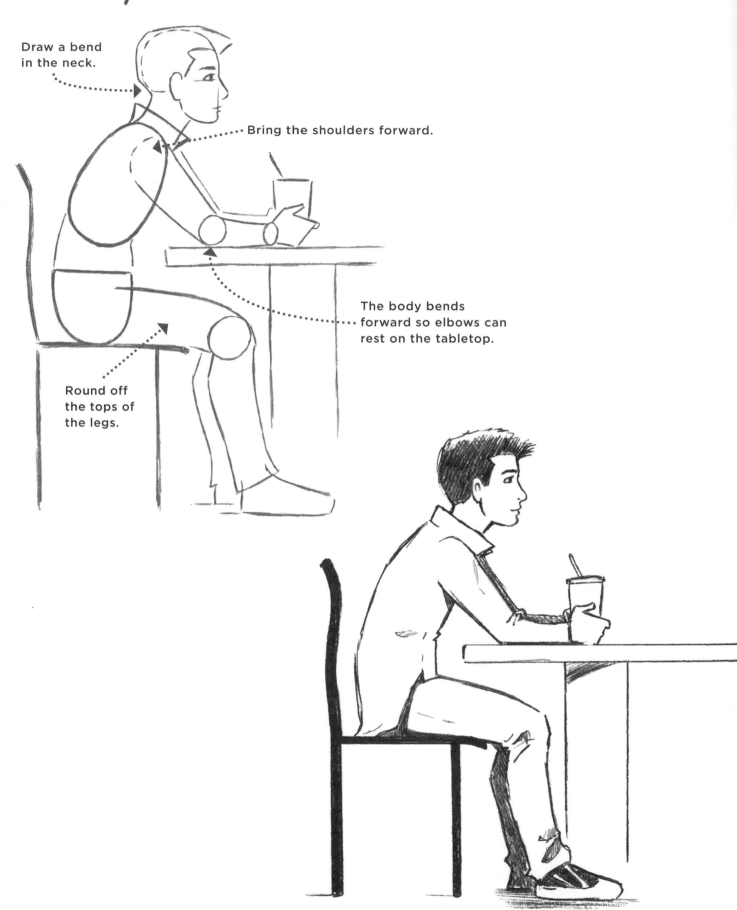

Draw a bend in the neck.

Bring the shoulders forward.

The body bends forward so elbows can rest on the tabletop.

Round off the tops of the legs.

Practice Page

Use the blank pages in this chapter to practice your final drawings based on the one-step constructions.

INDEX

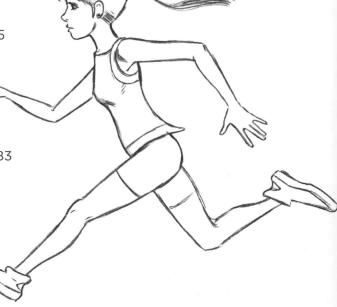